P9-BIO-723

J

"When making their own choices, children develop their creative thinking and problem solving skills, as well as generate self-confidence. *Art Workshop for Children* gets to the heart of composing an enriching environment for children to explore the possibilities in process-art making. Written for both the art educator or someone who is insecure about the creative process, Barbara Rucci expresses poignantly the value of fostering children's creativity through art making."

—Samara Caughey, owner and creator of the children's art studio *Purple Twig* in Los Angeles, California

"*Art Workshop for Children* is, in itself, an inspired piece of art. Every page is filled with beautiful photos of child-led artwork and creative experiences that will leave you thinking, "I can't wait to try this with my child!" As you read along, you will not only be inspired and encouraged by these two ladies but their creative passion will ignite the creative passion in you too."

—Deborah J. Stewart, M.Ed., early childhood educator, author of *Ready for Kindergarten!*, and creator of the *Teach Preschool Blog*

"If you have been nervous about trying art at home with your kids, *Art Workshop for Children* will give you all the tools you need to get fearlessly creative! From supply lists to easy and colorful art projects to information on child development, this book is a complete guide that will empower your children to become the best kind of creators: artists from the heart who relish in the process of making."

—Ana Dziengel, architect and award-winning furniture designer, creator of the children's art and design blog *Babble Dabble Do*, and mother to three young art explorers

"This book is an inspiring resource for any parent or caregiver, even if you have no background in art. It's filled with easy to follow, unique art activities that honor the child's creative process."

—Megan Schiller, teacher and founder of *The Art Pantry*, a design studio specializing in children's creative play spaces

"*Art Workshop for Children* is a rich and inspiring resource for parents, teachers, and caregivers. On every page you can feel their love for children and teaching with a gentle hand. It's all about the child and exploration and how–through self expression and critical thinking–children become creative thinkers."

—Amber Scardino, owner and Instructor at *Wee Warhols*, a children's art studio in Austin, Texas

"Barbara has that magical combination of wow-factor inspiration and practical, smart guidance. Accompanied by Betsy's thoughtful and thought-provoking wisdom, this book is a wonderful guide for parents and teachers."

—Cathy James, early childhood educator, author of several books including *The Garden Classroom*, and founder of *Nurture Store*, a children's creative learning blog

"This is my all time favorite process art book for kids. Each project is thoughtful, engaging and full of rich layers. I highly recommend this incredible resource for valuable art experiences for kids. *Art Workshop for Children* is a fantastic and inspiring book!"

—Meri Cherry, Reggio-inspired art teacher in Los Angeles, California, and creator of the children's art blog *Meri Cherry*

"*Art Workshop for Children* is a fantastic guide to help parents capture and nurture those wonderful creative years of early childhood, presenting a practical balance between the freedom of exploring as well as learning skills and techniques. Even if [readers] implement just a few of the fabulous suggestions and ideas, we will have happier and more creative kids growing up all around us!"

—Maggy Woodley, creator of the children's arts and crafts blog *Red Ted Art*, and author of the book *Red Ted Art: Cute and Easy Crafts for Kids*

"*Art Workshop for Children* is both a gift for the eyes and a practical guide for nurturing a culture of creativity in your family or classroom. With practical ideas for choosing authentic art materials, presenting art experiences, and displaying children's artwork thoughtfully, Barbara Rucci has created more than just another children's art activities book."

—Kate Gribble, mother of two and homeschooler inspired by the Reggio Emilia approach, and creator of the inquiry-based learning blog *An Everyday Story*

"*Art Workshop for Children* is a book for parents who want to raise inventors, dreamers, curious explorers, and creative problem solvers. By breaking down each art exploration into simple, at-home workshops using basic supplies (most of which can be found around the house), Bar shows us that it's not important whether your child makes a beautiful piece of art, its their experience during the *process of creating* that really shapes and influences their young minds."

—Jennifer Bryant, founder and head button-sorter at *Small Hands Big Art*, a children's art studio in Charlotte, North Carolina

Brimming with creative inspiration, how-to projects, and useful information to enrich your everyday life, Quarto Knows is a favorite destination for those pursuing their interests and passions. Visit our site and dig deeper with our books into your area of interest: Quarto Creates, Quarto Cooks, Quarto Homes, Quarto Lives, Quarto Drives, Quarto Explores, Quarto Gifts, or Quarto Kids.

First published in the United States of America in 2016 by
Quarry Books, an imprint of
The Quarto Group,
100 Cummings Center,
Suite 265-D,
Beverly, MA 01915, USA.
T (978) 282-9590
F (978) 283-2742
QuartoKnows.com

Quarry Books titles are also available at discount for retail, wholesale, promotional, and bulk purchase. For details, contact the Special Sales Manager by email at specialsales@quarto.com or by mail at The Quarto Group, Attn: Special Sales Manager, 401 Second Avenue North, Suite 310, Minneapolis, MN 55401, USA.

10 9 8 7 6 5 4 3

ISBN: 978-1-63159-143-3

Library of Congress Cataloging-in-Publication Data

Names: Rucci, Barbara (Barbara B.), author. | McKenna, Betsy.
Title: Art workshop for children : how to foster original thinking with more than
 25 process art experiences / Barbara Rucci, Betsy McKenna.
Description: Beverly, Massachusetts : Quarry Books, 2016.
Identifiers: LCCN 2016029196 | ISBN 9781631591433 (paperback)
Subjects: LCSH: Child artists. | Art--Technique. | Creative thinking in
 children. | BISAC: CRAFTS & HOBBIES / Crafts for Children. | CRAFTS &
 HOBBIES / Mixed Media. | FAMILY & RELATIONSHIPS / Activities.
Classification: LCC N351 .R83 2016 | DDC 372.5/044--dc23
LC record available at https://lccn.loc.gov/2016029196

Design: Megan Jones Design
Photography: Barbara Rucci

Printed in China

ART WORKSHOP for children

How to Foster **Original Thinking** with more than

25

Process Art Experiences

BARBARA RUCCI

Essays by Betsy McKenna, Reggio-Inspired Educator

Contents

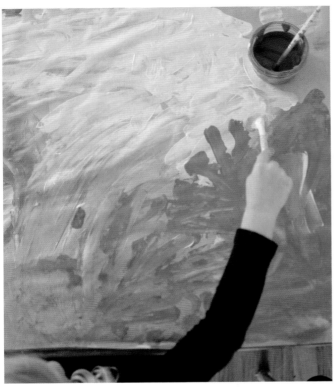

Preface

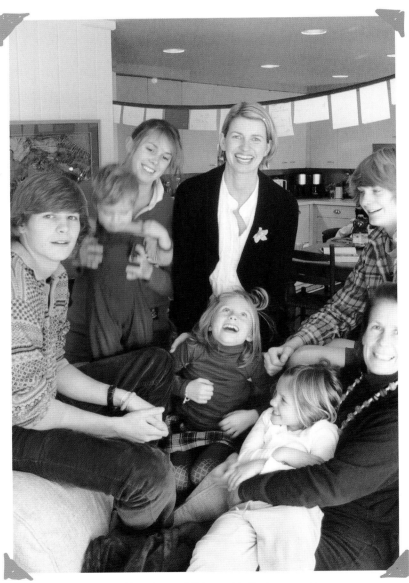

Betsy and her three children with Barbara and her three children, celebrating a birthday.

All children need just one adult in their life who will cultivate the dawning of their creative process—an influencer of sorts, someone who will model an authentic approach to exploring hunches and ideas. My exposure to the creative process began in the kitchen of my father's garage apartment. It was a utilitarian space with less than the basics for cooking and eating. But most notable was the back wall with repurposed storage. Stacked on shelves 12 by 12 feet (3.7 x 3.7 m) were hollowed-out Diet Rite cola cans. Each can held objects of little value but great intrigue: wires, bottle caps, bread tags, switches, string, adhesive, beach glass, stones . . . possibilities alive! Anyone could contribute to the collection and anyone could access the materials. There were no rules.

It was here that I started to tinker and play with a variety of materials that helped me interpret the way in which I saw myself in the world. It was here in my dad's kitchen that I was encouraged to ask questions and seek answers. A lifelong gift. Evermore thanks, Dad, for being my early influencer.

Impressionable childhood experiences tend to repeat themselves in parenthood . . . and so began my version of the "Diet Rite cola can wall" that I prepared for my three children in our home. The space and materials had purpose and were informed by each child's interests and emerging passions. Aquarium tanks, a large chalk wall for drawing, a sunflower-filled tabletop, chocolate batter in muffin tins, and more . . . all messy works in progress, and all real and meaningful experiences.

Our house was host to many, one being the joyful, creative spirit of Barbara Rucci. Bar (as she is known to family and friends) was a college-level art major at the time I met her. She was my eldest child's first babysitter, a source of creative inspiration and ultimately lifelong friendship. She transformed our home into a process art studio. She

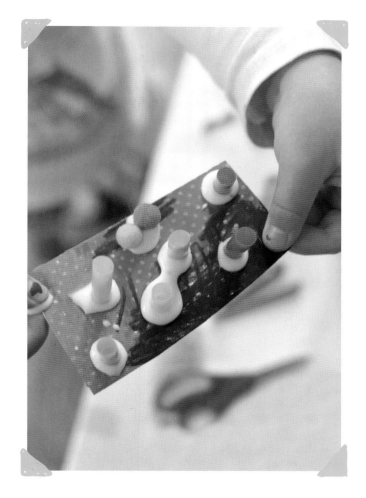

inspired all of us to appreciate the aesthetic beauty that existed within and around us. Bar was, and still remains, our family influencer. Evermore thanks, Bar, for being the creative catalyst for my trio and me. Wonder abounds!

Central to the creative process is the belief that anything is possible if you hone in on the lurking potential. Each of us is born with potential—of this I am certain. I smile when I think about this collaboration with Bar and I nod because it all makes sense.

I hope that this books serves as a source of inspiration and a catalyst for you to become an impressionable influencer in the life of your child.

—*Betsy McKenna*

Introduction

We Are All Artists

"The most beautiful world is always entered through the imagination."

—HELEN KELLER

In my opinion, **we are all artists**. We build our lives from scratch. We work with what we are given. We experiment, we express ourselves, we problem solve. We make mistakes but try again tomorrow. We explore new ideas; we make the best of what we have. Each and every day is a new creation, never the same as the day before. We are original. **We are artists**.

Creativity is our greatest asset. It lurks within our core, whether you know it or not. Most people that I meet, when I tell them that I write a creativity blog for children and teach art, the first thing out of their mouths is a version of this:

"Oh, I wish I could draw. My son, he loves art. But I'm not creative."

It takes all of my will not to grab them by the shoulders and scream a version of this at them:

"How wrong you are! Creativity is not just drawing. Do you cook, do you garden, do you do your own taxes? Can you form a beautiful sentence, are you witty, can you think on your feet? Creativity can be expressed in a hundred ways. Stop this nonsense that you are not creative!"

I'm not that bold, so I reply with a more subdued version. And then I focus on the child, because he is the **heart of the matter**.

Of course he loves art. What's not to love? There is no right or wrong! Exploring paint and clay and glue, tearing and cutting paper, discovering color through mixing and layering—these are all extremely tactile experiences. Making art is FUN.

Remember when you were a child and you spent your days building with Legos, dressing your dolls, making potions, lining up rows of army guys, creating an imaginary world outside among the trees, or just coloring? You were in the flow; hours went by and it felt like minutes. You were at your creative best. You were neither hindered by expectations nor thwarted by obstacles. Problems were solved in an instant because there were no rules. **Just your imagination**.

Somewhere, somehow, your creative life became smaller. It happens. You started school, you discovered you were good at soccer, you had homework, your life outside of home got bigger, and you no longer had the time for your imaginary worlds.

This is what I wonder: At what point did you stop thinking you were creative? Was it suddenly, when someone maybe commented that your drawing wasn't any good? Or was it slowly, when your interests changed and you never went back to your **childhood passions**?

Whatever the reasons, here you are. A grown-up, of sorts. You have your own children or grandchildren, or you teach children. And they love art. You might feel like this is out of your realm of expertise. You're not sure how to indulge their love of art because you yourself are not creative. What could you possibly teach them?

Here's the secret: You don't have to teach them anything.

This is the beauty of **process art experiences**. What this phrase means is that the emphasis is on the process of creating, not on the end result. It doesn't even matter what the end result looks like, and therein lies the beauty. There is no pressure, there is no perfect. The child is free to create, free to explore the materials, free to construct her own interpretations, free to express herself. **Free**.

This book is here to help you get started. It begins with a list of the most basic supplies and some tips on how to set up an art space, followed by twenty-seven art workshops to inspire and help children explore their creativity.

Each workshop provides an **experience**, which can be interpreted in many different ways. No two experiences unfold in the same way, which is why these workshops can be repeated again and again.

The **value** of exposing your children to a world of art making runs deep. By providing them with the tools they need to develop their creative muscles, you are helping them strengthen the connection between the hemispheres in their brain. This will help them later in life to reach their full potential.

The art room is a place where an accidental blob of paint becomes an element of the story, where mistakes are no big deal and just turned into something else. Where else can children express themselves so freely with no judgments? During the process of creating, children are also learning to observe, evaluate, experiment, and persevere. These are the building blocks of a happy, successful childhood.

Let's make a pact today: You will no longer think of yourself as "not creative." Now you know better. Providing your children with an art space and a few supplies is all you need to foster their original ideas and keep them familiar and comfortable with making stuff.

Let's raise **creative thinkers** who explore their world, express their dreams, embrace differences, and never lose touch with their inner artist.

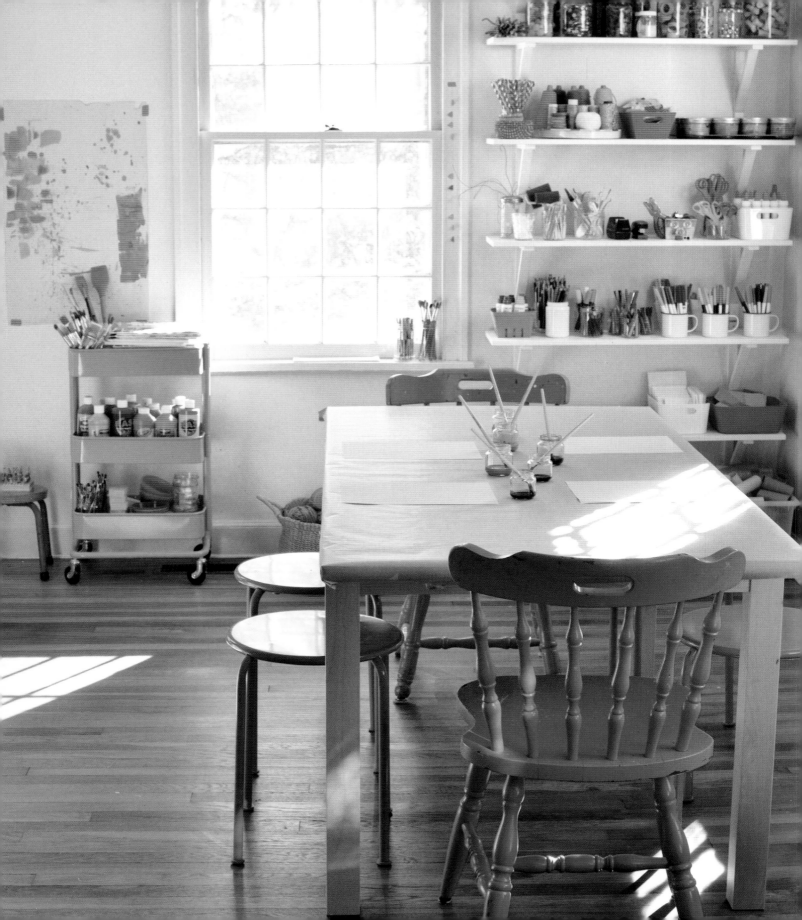

Chapter 1

How to Begin

"Creativity takes courage."

—HENRI MATISSE

I teach art to young children in my home. My art space is on one end of my long living room. On any given day, the floors are lined with drying prints, the table is covered with half-finished sculptures dripping with glue, and the sink is filled with soaking paintbrushes. It is an art-filled home, and I wouldn't want it any other way. (Except on the days when I want to rent a Dumpster and start over.)

My living room hasn't always doubled as an art studio. When my children were little and we were in a different house, I had a dedicated room off the kitchen that was used solely for the purpose of messy art making. There was even a sink! I wasn't teaching art in those days, but I did infuse my children's lives with creativity in a very simple way.

CREATIVE INVITATIONS

When my children were young, they spent lots of time in the art room. It wasn't always their first choice of activities—my girls loved singing and acting and my son loved any and all forms of running around outside with his neighborhood pals—but I had a method of arranging the art table in a way that would draw them in. I didn't know it at the time, but I was providing them with *creative invitations*.

This phrase was not in my vocabulary back then, but thank goodness it is now! I am a huge fan of creative invitations. I love them so much that I set them up for every art class. In fact, many of my art workshops in this book are creative invitations.

Creative invitations are simply an inviting way to set up the art table so that the child is captivated by the materials and excited to sit down and explore. It can be homemade playdough, small rolling pins, and some pompoms; or it can be watercolors and an interestingly shaped paper like long and skinny or a circle; or it can be a tray of collage materials, some glitter glue, and a big piece of cardboard. The main objective is to keep it simple, rotate the art materials that you have on hand, and entice your children to keep exploring their creativity.

WHAT IS PROCESS ART?

Inherent in the creative invitation is that it's about the process, not the product. Children sit down to create with no preconceived ideas, no "sample" to look at or outcome to work toward, no right or wrong. It's just them and the materials and the freedom to explore.

Process art is the most favorable way for young children to experiment and engage with the materials in the art room. Whether the supplies are on the table or nearby on a shelf, the children are making choices and decisions unto themselves. Process art

is about discovery, investigation, and enjoyment of the materials without the notion of an end result.

My friend and co-author of this book, Betsy McKenna, puts it so well when she says, "Process art represents the voice of the child, an authentic expression of what the child is thinking and feeling. It is through the free exploration of materials that a child can take risks, gain increased self-awareness, and build confidence to experiment with new ideas."

By giving our children the freedom to interpret the materials in their own way, they are creating original work that is inherently personal. With process art, it is the child's choice to be finished and to walk away; or to come back later; or to stumble upon something new and switch gears; or to ask for help. It is her voice and her choice.

My son and daughter when they were little in our art room. I set up "creative invitations" at the art table to draw them in.

LEARNING SKILLS

I believe that all art, up until the age of three, should be simple, process art invitations. Children this young should never come across a craft activity where they have to follow step-by-step directions. This would turn them off from making art because there is nothing creative or personal about copying a craft. They are too young to make it turn out the way it is supposed to, so there is a very real risk that they will feel bad about themselves. No child should *ever* feel badly about making art!

After the age of three, children are ready to start learning some skills, things like using scissors, squeezing little dots of glue, using a watercolor set, and pulling off little pieces of tape. They will bring these skills with them when they begin to explore their new ideas.

As they get older, they can build their skill set. I like to introduce them to sewing, printmaking, elements of the face, stringing beads, and so on. On days when we have free choice in art class, the children can now combine their bits of knowledge to create more intricate works of self-expression.

(If you are wondering when a good time *is* to introduce crafts with your child, I would say that by about age six some children will show interest in making something specific, like friendship bracelets or pompom necklaces. Children will need the

After setting up a simple painting invitation with just some brown table paper and paints, my son and his friend explore the materials and discover new ways to paint. They are enjoying the process of making art without any pressure of an end result.

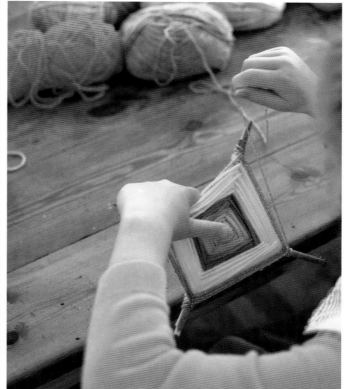

When children are old enough to learn some skills, such as wrapping yarn around twigs to create a God's Eye, they build upon their creative language which supports their next good idea.

fine motor skills to feel successful, so wait until they are ready. Crafts can be fun for this age because they can be done with friends, which lends a wonderful social component.)

HOW TO USE THIS BOOK

In this book, my workshops vary from very simple creative invitations, to more involved workshops that have some steps, to collaborative projects for a group of children. You are welcome to start anywhere, but there *is* a chronology, with the first workshops being simpler using just a few supplies. You can, however, just as easily jump around, because each workshop is adaptable to your child's skill level.

For example, say you have a three-year-old who is interested in making the cardboard robots. For children this age, I would encourage them to stack and glue some boxes together, glue on some other recycled materials if they would like, and then paint. It certainly does not have to resemble a robot. Children are exploring the materials, learning to glue and to use paint, and creating something that can be used in their imaginary play.

I would love for you to use this book as inspiration to set up creative invitations for your child. Once you get the hang of these invitations and understand their value in fostering original thinking, it will be easy to weave them into your new creative life.

There is also tremendous value in the essays written by Betsy, who has many years of experience working in a Reggio-inspired early childhood classroom and now works as an educational consultant and leadership coach. Yes, she is that impressive. I have known Betsy for almost thirty years—since I was a teenager and babysat for her children—and each and every time she opens her mouth to speak I want to have a notepad handy. She is so eloquent

This table is set up a simple "creative invitation," with paper, water-soluble crayons, and water, which entices the children to explore.

and says such important things that are deeply rooted in her knowledge and understanding of young children. Over the years, her shared wisdom has shaped my parenting style.

Most important, spend time perusing the next chapter, and create an art space for your children. It is one of the best gifts that you can give them—a place all their own where there are no judgments or creative boundaries, where they are free to tinker and mess about with materials, and use their hands to make original work.

If we are to raise creative thinkers, then we must place the utmost value in creative expression. Giving children a dedicated space, some interesting materials, and the opportunity to slow down and use their imagination is important, not only because it teaches them to observe, innovate, and persevere, but also because it feeds their soul.

→ CREATING YOUR ART SPACE

Every child needs a place to play. From the moment they are born we start collecting toys and putting them in baskets, which eventually leads to creating a playroom. In the playroom, children learn to socialize and share, they find their interests and use their imaginations to make up games and stories, and they see and try different points of view by watching and copying their friends. Healthy play makes for happy children who discover their place in the world.

It will come as no surprise that in my home, the art room is equally as important as the playroom. If we think of our children's art room as a place where they can integrate creativity and self-expression into their everyday lives, then carving out even just a small area in our home for some paper and art supplies becomes of great value.

In the art room, children work with their hands and innovate. The colorful and inviting materials feed their imagination, and the dedicated space gives them the freedom to explore their ideas. Open-ended creativity in the art room empowers our children to mess about, take risks, and discover that they have good, original ideas.

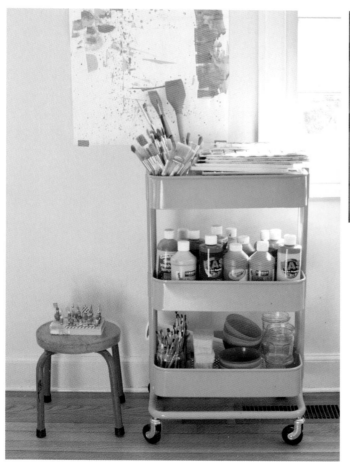

LEFT: The art cart is where I keep the painting supplies. Once the children have learned the rules and routine, this painting cart becomes self-serve.

ABOVE: The top of the art cart holds stacks of watercolor paints and several containers of brushes.

Speaking for myself, one of the main reasons that I continue to expose my children to new art materials and encourage them to tinker about with their hands well into their teens is not because I hope they will become artists—indeed, their passions lie elsewhere—but to give them a lifelong appreciation for art and aesthetics, and to make sure that they are able to think in a unique and different way. This will set them apart, and what mom doesn't want that?

My Art Space at Home

When it comes to creating an art area in your home, there are many ways to make this happen that don't involve a lot of space or money.

I teach art classes to children in my home, and my art space, believe it or not, is in my living room (see the photo on page 10). There are times throughout this book that you will perhaps catch glimpses of the couches, fireplace, and TV that are right next to the art table. We do big, messy art on that table, and other than a few paint splats on the wall (that wash off), the rest of the living room is unscathed.

To make an art space in my house, I built some simple shelves onto the walls and painted them the same color as the walls. I bought an inexpensive table from Ikea that has an extra leaf so I can fit up to eight children comfortably (but usually I just have six children in class at a time). I also have bins that store my recyclables, a self-serve art cart for painting, and a set of drawers that stores paper. It's not a big space and the setup is simple, but it works well and the children have a sense of freedom and choice when they enter the room.

LEFT and RIGHT: The shelves are stocked differently at each level. On the first level there is paper. Next up are the drawing supplies, like crayons, markers, pencils, chalk markers, and paint dots. Both shelves are very accessible. The third shelf is where I keep all of the tools, like scissors, glue, tape, and hole punches. It's just high enough that it's out of reach to the littlest, but reachable to fours and older. The next shelves are mostly materials that I set out on the table during a workshop, or extra supplies. The children are welcome to use any supplies they need at any time.

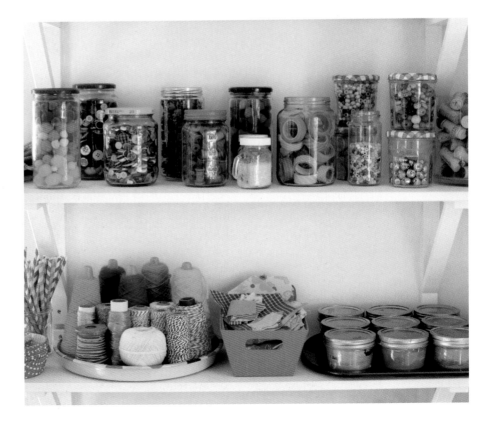

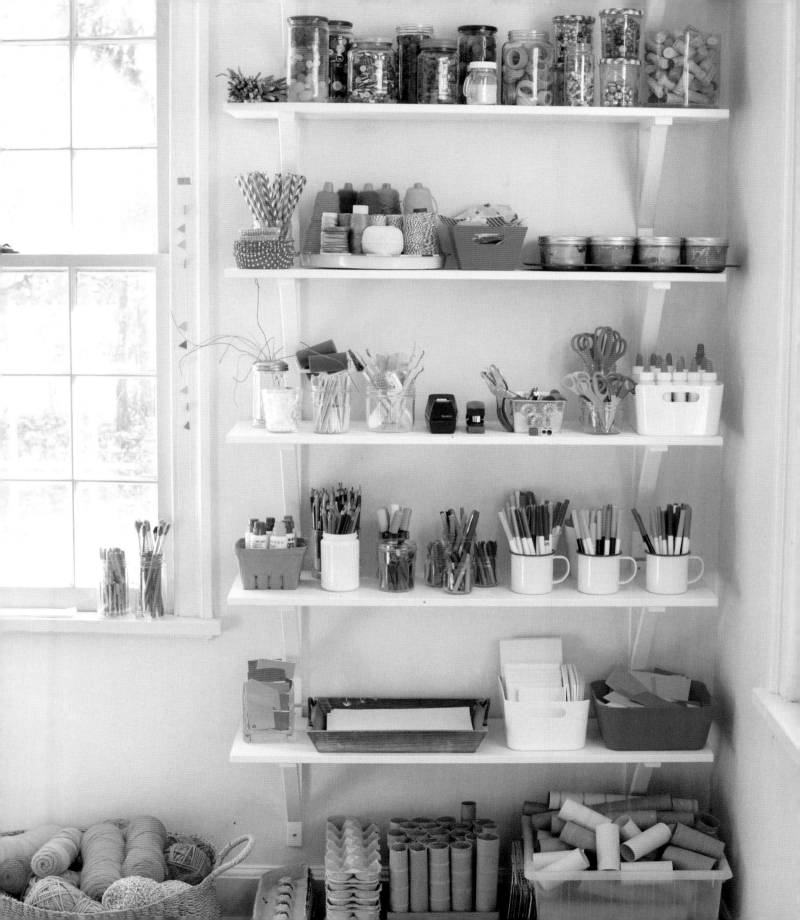

TIPS AND RULES

(For creating a functional art space at home that fits everyone's needs)

1 Young children want their mother or caregiver to be nearby, so choose an art space for your child that is close to where you naturally spend your time.

2 Pick a place where you wouldn't mind leaving things a bit messy here and there. Children like to work in spurts, so often they will walk away for a while, then come back when they've found new inspiration. I call this "working like an artist." Keep a large (attractive) garbage can close by for easy cleanup.

3 When setting out supplies, pick only the ones that you are completely comfortable with your child using independently. This will encourage spontaneous making. Keep the "ask first" materials in a closet.

4 Less is more. Don't put out every art supply you own. Curate an alluring collection of materials, and then consider rotating them out every once in a while. New materials invite exploration.

5 Save glass jars to store art supplies. When children can see their supplies and they are displayed in a captivating way, they will be drawn in to use them. (Fact: Not once in my sixteen years of using glass jars has any of them ever been dropped or broken by a child.)

6 Keep a few bins or baskets close by for saving and storing recyclables. This can become a family affair.

7 For those who are mess-averse, here are some ways to contain the mess: Cover the table with newspaper for easy cleanup, give your child a tray to work on, and have a few old T-shirts nearby (on some hooks perhaps) to use as smocks. Also, if it's summertime where you live, your child can work outside!

8 My rule for table size: Four-year-olds and under should sit at a small table where their feet can touch the floor. At about age five, they can transition to a grown-up table and sit on their knees if they need more height. Often my four- and five-year-old students stand to work, preferring the freedom to move.

9 Think of your children's art area as an art lab: a place for exploration and discovery. They will not always be making "art" as much as they will be playing with materials in their own way (remember, there's no right or wrong here) and working on their next good idea.

Here are some simple and achievable
art space ideas for your home.

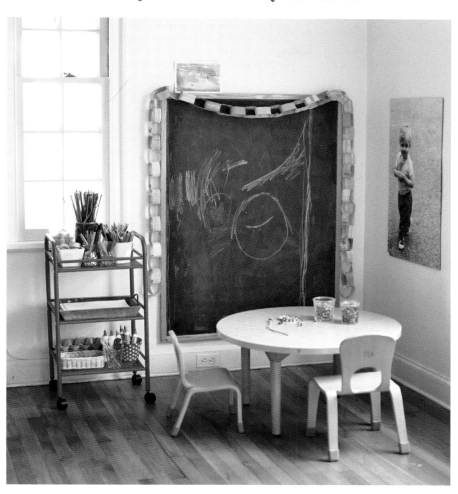

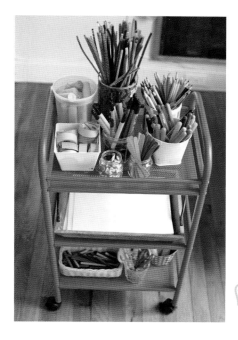

The Art Corner

Choose a room that is not too far away from the action. For example, the kitchen or family room might have a perfect corner that can be converted into "the art corner." Or even the dining room or living room! Just make sure that you have a floor surface that is easy to clean. This corner space above has a wonderful round table that can seat a few friends. For children ages four and under I recommend a smaller, kid-sized table. This art corner also has a nice big chalkboard and a beautifully curated art cart.

The Art Cart

The art cart is the best idea yet! It houses a colorful and enticing selection of creative materials and tinkering basics, can be rolled to other areas of the room if needed, and takes up very little space. You can store other art supplies in a closet and then just rotate them whenever you feel like the art cart needs a makeover. Children love to see new materials, so rotating them is beneficial to keeping creativity alive. On this art cart there are magic markers, colored pencils, colored tape, craft sticks, chalk, pipe cleaners, beads (out on the table), a tray of paper, crayons, scissors, glitter glue, and some recycled egg cartons.

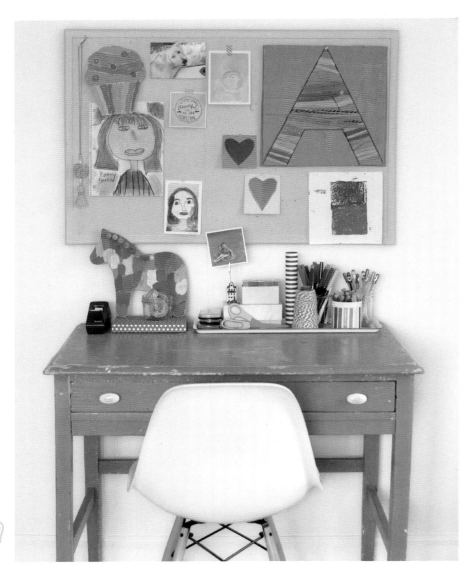

The Art Station

If you are really crunched for space but you want your children to have access to some art materials, create an art station with an art caddy. Putting together an art caddy is a very simple and practical idea. These caddies live on top of this Ikea Alex Drawer unit. The drawers are a perfect place to keep paper and other flat supplies like watercolors. Your child can pick up the art caddy and take it to the kitchen table, his room, or just on the floor. When he is finished, he can bring it back to the art station.

The Art Desk

Filling a desk with a few art materials, and setting up an easy corkboard display above, is all your children really need to feel inspired. Whether the desk is set up in their room, a playroom, the kitchen, or any small space in the house, the key is to make it an area that is just for them—a place where they can go to draw, snip, staple, stamp, glue, tape, or paint whenever they feel the need to create. Choose a desk that has a drawer where paper, watercolors, and other supplies can be stored easily.

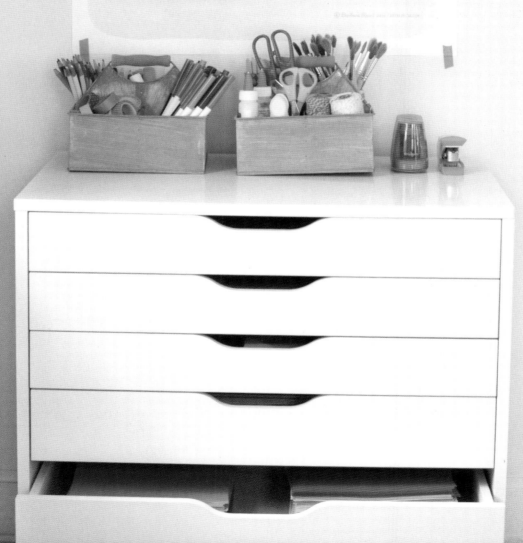

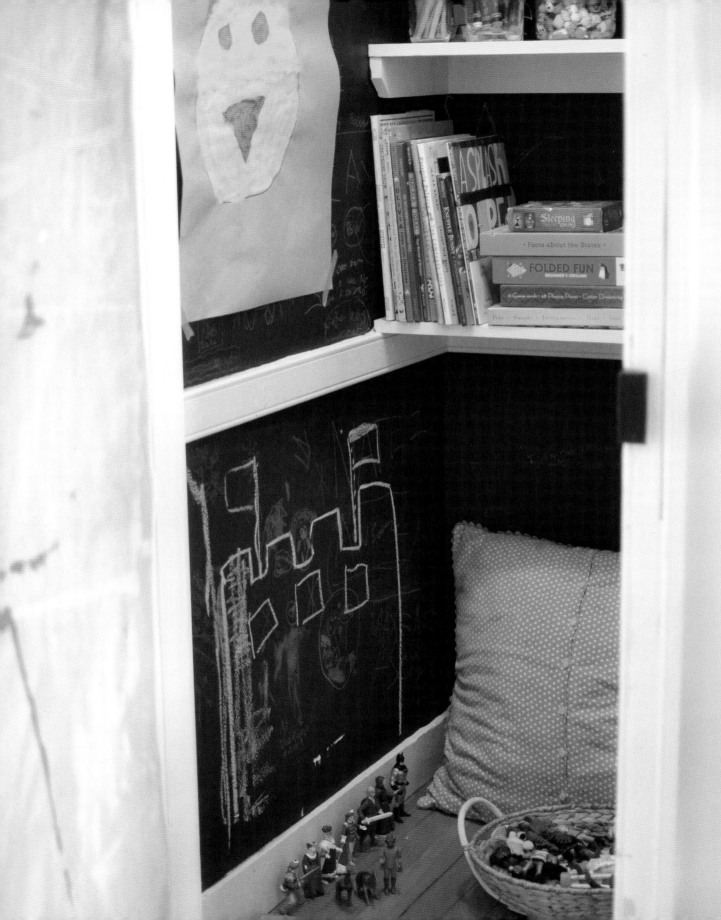

The Art Closet

I know several families who say they have converted a closet into an art space. Their children play and create in there like it's their secret hideout, and the mess stays inside. It's a really great solution if you don't have much space in your home, and if you want to keep the mess contained. This closet to the left was painted with chalkboard paint. Art supplies are stored among other good hideout materials, like books and games.

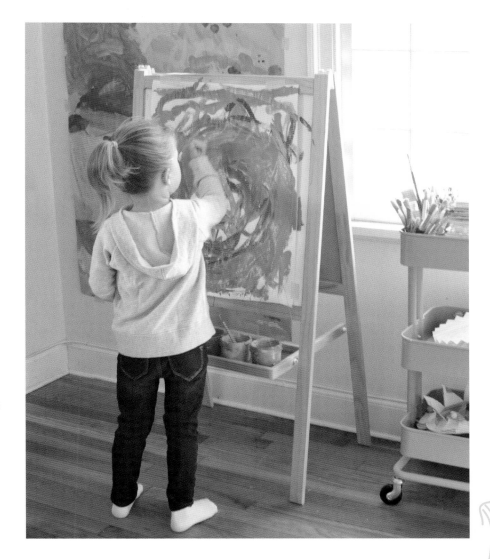

The Art Easel

Making art in a vertical format, whether painting or drawing, allows your children to work big, using their large arm muscles and sometimes their whole body as they wiggle and dance about. If you get an easel that has storage on both sides, then your child can use one side for painting and the other side for drawing. The easel then becomes the art station. In the summer we bring our easels outside and use spray bottles filled with water and paint to make some drip paintings—a wonderful way to explore gravity and color blending.

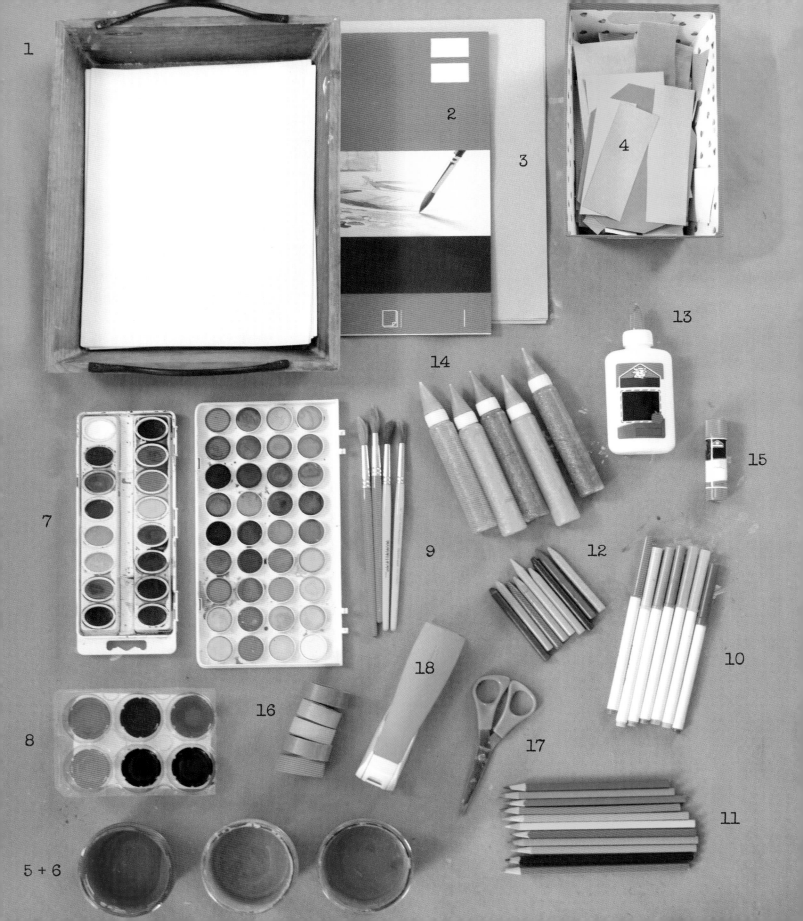

⟶ GATHERING MATERIALS

Beginner Art Supplies

Here is my list of the eighteen most basic supplies that you will need to fill your art shelves. You can do so much with these materials. In fact, twenty of the twenty-seven workshops in this book use only this list! All are nontoxic.

PAPER

1. **Plain white paper.** I just buy printer paper in bulk. Good for basic drawing and coloring.

2. **Watercolor paper.** A lightweight 90 lb. paper is good enough. Buy larger and then cut it down.

3. **Sulphite paper.** A nicer version of construction paper, sulphite paper holds paint nicely. I buy gray and white.

4. **Colored paper.** We use colored paper mostly as collage material.

PAINT

5. **Tempera paint.** Start with Crayola washable in basic colors, and get a large white to mix light colors.

6. **Jars for paint storage.** You can buy half-pint canning jars, or use your own recycled jam jars.

7. **Watercolor palette.** The left one is washable Crayola, the right has more colors. We use both.

8. **Liquid watercolors.** These have very vibrant, deep colors that cover larger surfaces. Any brand is fine.

9. **Brushes.** I buy First Impressions round #8 and #10. I also love brushes from Ikea.

DRAWING

10. **Markers.** Any washable Crayola markers will work. Put them in a basket for easy access.

11. **Colored pencils.** Any brand that is convenient to buy will do. An electric pencil sharpener is useful.

12. **Crayons.** We use Crayola brand. I soak them in warm water for a few hours to take the papers off.

TOOLS

13. **White school glue.** We use Elmer's, but any brand will be fine.

14. **Glitter glue.** These are ArtSkills jumbo, but any glitter glue that you can find will be great.

15. **Glue stick.** Any brand will do.

16. **Colored tape.** This is also known as washi tape; we have lots of plain colors and patterns.

17. **Scissors.** Ikea has a great set of children's scissors.

18. **Stapler.** Any stapler will do.

FOR PREP

- **Brown roll of paper.** I buy the brand Pacon in the size 3 x 100 feet (91 cm x 30.5 m). You can also use newspaper.

- **Masking tape.** This is the best tape to adhere paper to the table.

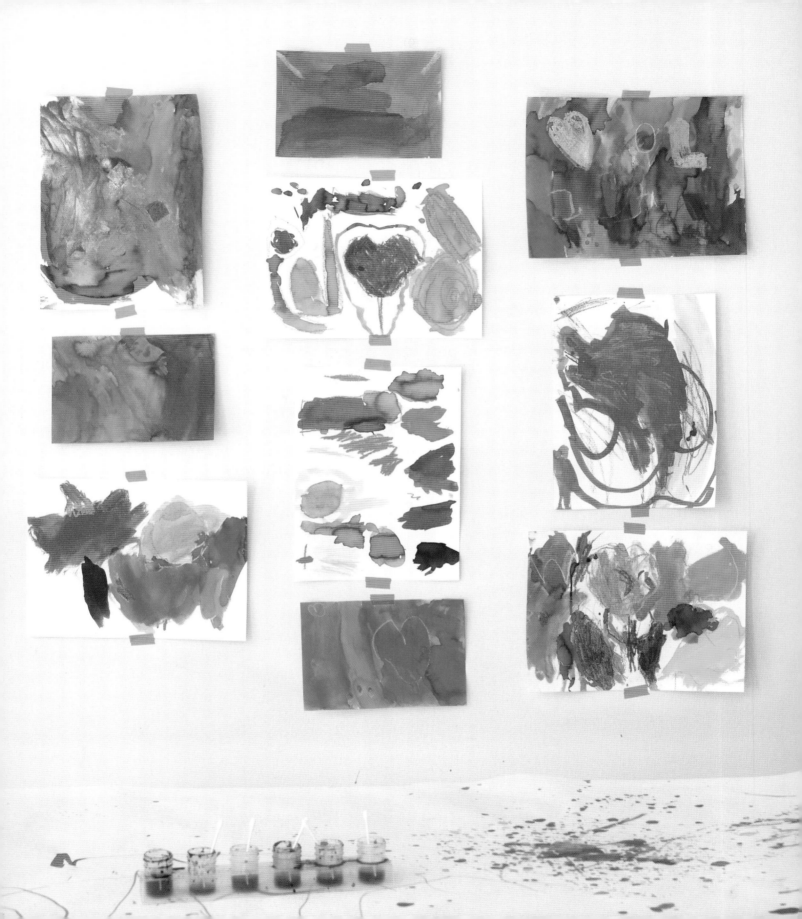

Chapter 2

WORKSHOPS // Beginning

"It took me four years to paint like Raphael,
but a lifetime to paint like a child."

—PABLO PICASSO

Children arrive in this world ready to explore and learn. We can begin to introduce them to artistic materials at an early age. Babies can investigate edible paint with all of their senses. Two-year-olds love mixing paint colors as much as they love cleaning their brushes in water. Three-year-olds can look into a mirror and begin to form the simple shapes of a face. And four- and five-year-olds thrive in an environment that supports their ideas with varied materials right at hand. In this chapter, children discover and rediscover the many different ways in which paint can spark their imaginations.

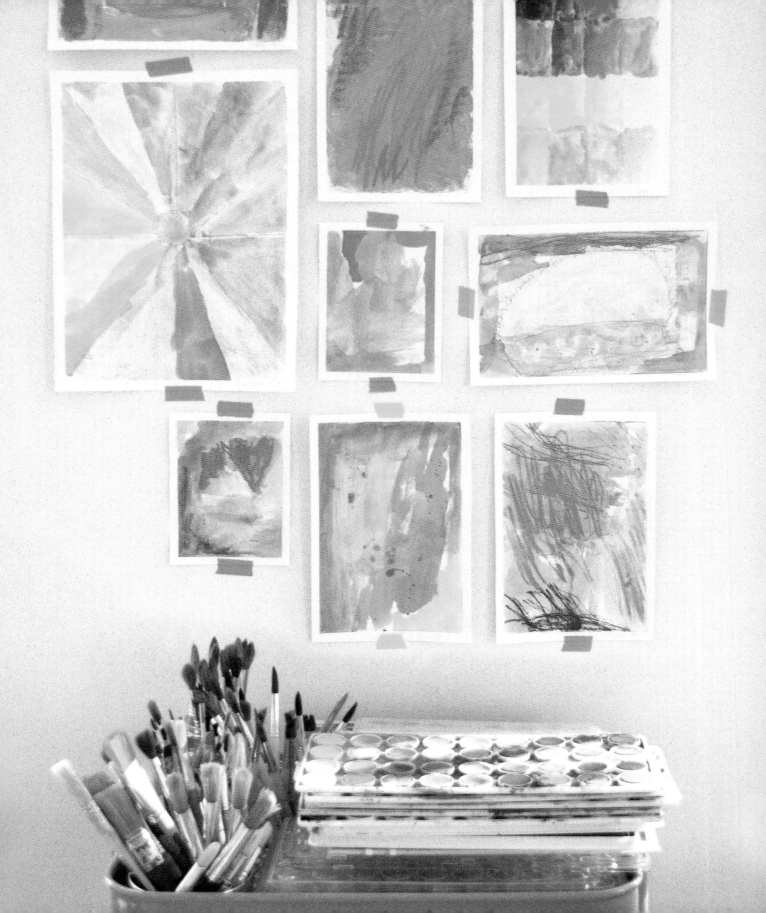

SIMPLE FRAME PAINTINGS

This is one of my very favorite art invitations. It is quick to set up, the paper size is small and accessible, and it is perfect for any age—toddler to adult!

GATHER YOUR MATERIALS

- Watercolor paper
- Piece of cardboard (optional)
- Tape (painter's or washi)
- Watercolor paints
- Paintbrush
- Glass of water
- Damp sponge or paper towel

PREPARE YOUR SPACE

Watercolors are not that messy. You don't need to cover your table. Tape a piece of watercolor paper onto a piece of cardboard, or just a larger piece of scrap paper, creating an even border around the edge. Or you can simply tape the watercolor paper to the table!

A little bit of tape around the edge of the paper creates a clean border that frames the artwork.

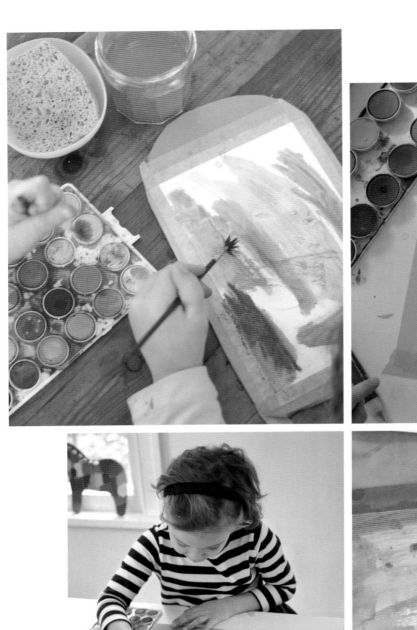

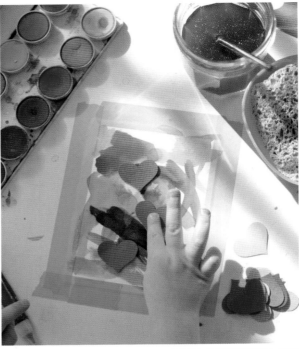

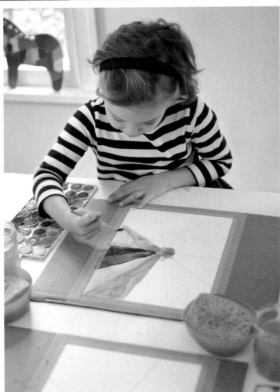

Pulling off the tape to reveal the crisp, white border never ceases to be a thrill and allows each painting to feel important.

THE PROCESS

- Simply set up the supplies and leave out this invitation for your children as often as you'd like. Each time they will enjoy covering the small, bordered space with paint.
- Use this workshop as an opportunity to encourage your child to fill the whole page.
- Wait until the paint has been absorbed by the paper before slowly taking off the tape. Pulling off the tape to reveal the crisp border never ceases to be a thrill!

Overheard:
"I'm painting you a surprise. Don't look!"
—Mason, age 4

OBSERVATIONS

I use this invitation many times a year during art class, and also with my own children. There is something about painting a small, limited space that draws the children in and motivates them to just sit down and put paint on paper. In art class, I often set this up at another table for the children who have finished our main workshop early. It is such a wonderful, open-ended, child-led activity with no instructions that allows them to be free. And the border makes every painting look important!

VARIATIONS FOR NEXT TIME

- Put some crayons or oil pastels out so that the kids can experiment with both materials (see page 37 for more on this technique).
- Set out some small collage pieces and glitter glue, along with the watercolors.
- Set out a ruler and a pencil for children to use before painting. We have experimented with grids, sunbursts, and also just free drawing with the ruler (see page 93 for more).
- Collect many of these small paintings and hang them together. They are quite stunning when hung in a gallery wall style.

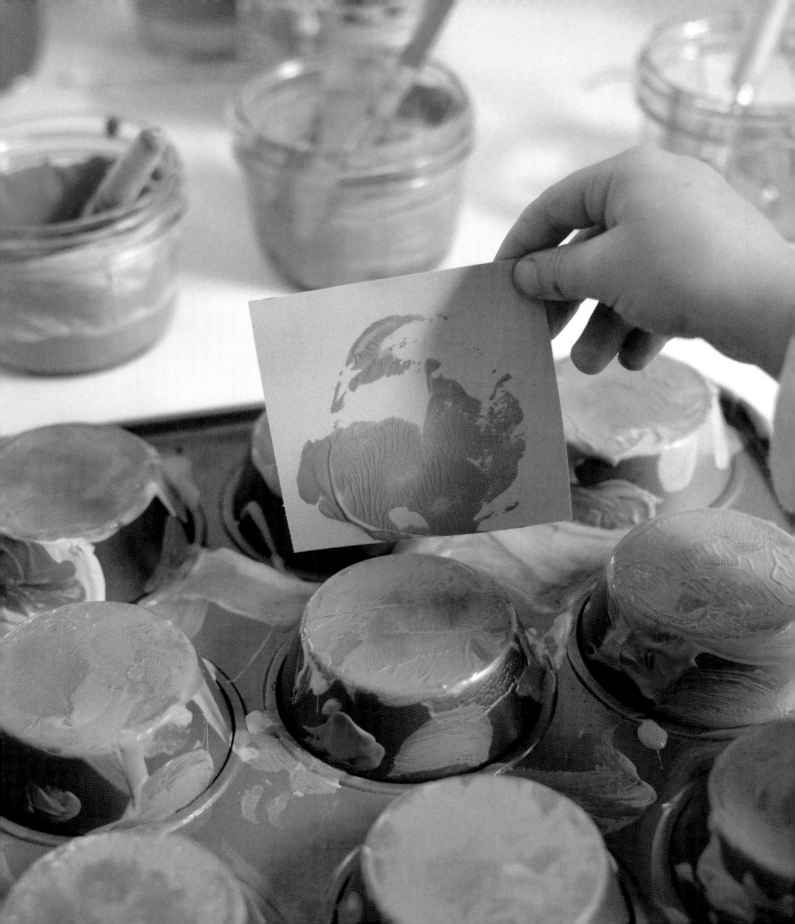

→ # Workshop 2

MUFFIN TIN PRINTS

When children are allowed to use paint to explore irregular items, their faces light up.
How silly to paint on something used for baking muffins in the kitchen!

GATHER YOUR MATERIALS

- Paper cut down to small squares
- Tempera paints
- Jars
- Brushes
- Muffin tin
- Flat object for pressing down (we used lids, but one child sought out a toilet paper roll instead!)

PREPARE YOUR SPACE

Cover your table with newspaper. Find space on the floor or counter and lay out more newspaper for drying the prints. If you are working with multiple children, write their names on the back of their papers with a pencil. Prepare the paint jars. Give each child 10 to 20 small squares of paper.

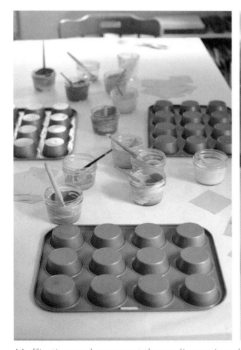 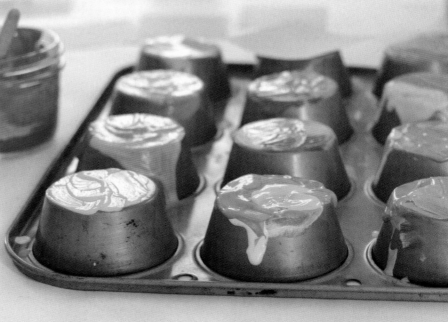

Muffin tins make a great three-dimensional material for painting and exploring "hills and valleys."

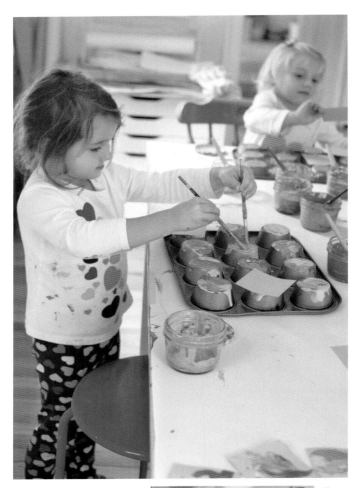

As the children become more familiar with the printing technique, they develop their own unique style.

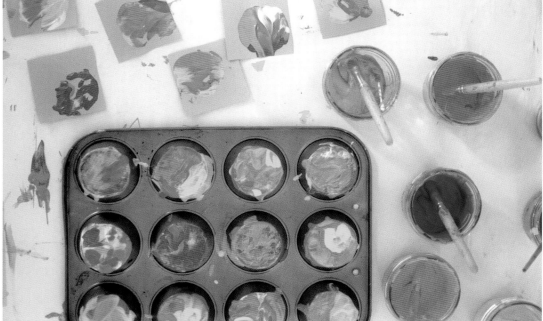

THE PROCESS

- First, let the children explore their new medium for a bit, feeling the paint run over the smooth, metallic surface of the muffin tin.

- Next, show them how they can transfer the paint from the top of the muffin to the paper by pressing down gently. This is called a "print." Let them experiment with this new technique on their own. There is no right or wrong, just the child's own personal interpretation.

- As their area fills up with prints, they can bring them over to the drying station.

OBSERVATIONS

As the children sat down at the art table, they began testing the paint on the "hills and valleys" of this new, shiny surface. Some painted the whole muffin tin with one color, while others painted just the tops with different colors. As they learned how to print, they discovered that a thin layer of paint on their muffin "hill" meant a very light print, so they began to make their paint thicker for a more saturated print. They learned that using the lid of a jar to press down on the paper meant a stronger image, and maybe some oozing of their paint. As they became more familiar with the printing technique, they all developed their own unique styles.

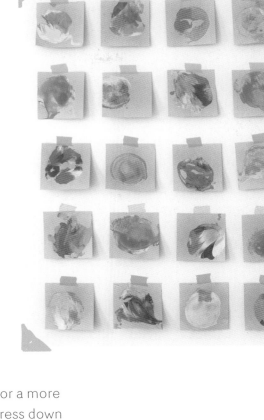

VARIATIONS FOR NEXT TIME

- Use black paint on white paper, or white paint on black paper.

- Use white or black paint on different colored papers.

- Give children cotton swabs to draw in the paint before printing.

- Flip the muffin tin over when all 12 tops are painted and then press it onto a big piece of paper so that all of the circles are captured on one page.

- Use the table paper to print on, creating a large work of art that could be cut up and used as wrapping paper.

- Make a collage from the prints (see page 89).

Overheard:
"Look! I'm painting with two brushes."
—Lucy, age 4

Ultimately, I had hoped to give space and time for each child to develop his or her own individual voice. As a parent, I hoped to mirror back a sense of self-confidence that empowered them to make their own decisions, try new things, and test their hypotheses. It was through trial and error with my trio that I gained clarity. I realized that my opinions were far less important than the ones they formed on their own. I also realize that they are only going to become more capable and competent if they are allowed to do things for themselves, regardless of outcome.

This seed of knowledge is ever growing as I continue to live into my adult role both personally and professionally. It is with gratitude that I thank my three children for being a constant source of inspiration.

—Betsy McKenna

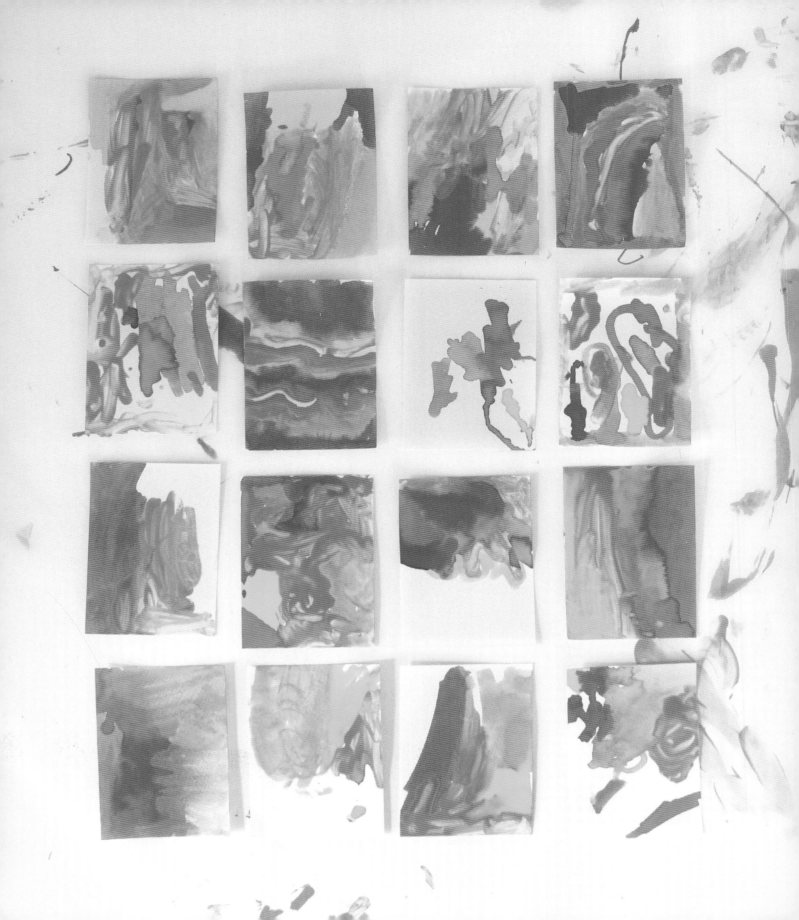

COTTON SWAB MINI WATERCOLORS

Cotton swabs are a wonderful invitation for children.
They are little and fit right into their fingers.

GATHER YOUR MATERIALS

- Watercolor paper cut to a small size
- Liquid watercolors
- Small jars or a plastic egg carton
- Cotton swabs

PREPARE YOUR SPACE

Cover your table with paper—something that will soak up the excess paint—or have your child work on a tray. I cut the paper to about 3 x 4 inches (7.6 x 10.2 cm) or sometimes in squares. The small size is just right for the small cotton swabs. I give each child eight to ten pieces and I write their names in pencil on the back.

Children use cotton swabs to paint on small paper with liquid watercolors.

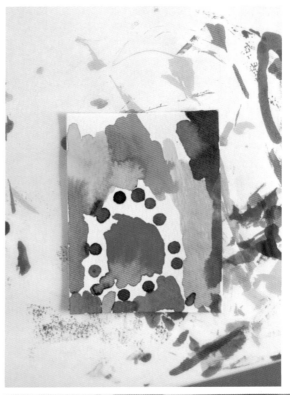

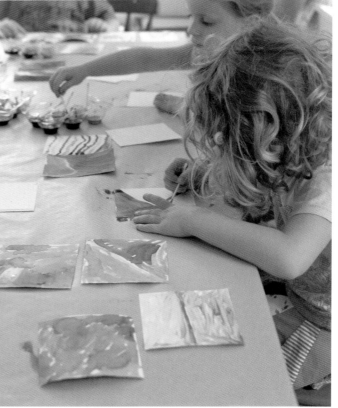

As the children become familiar with their materials, they explore color and shape within their mini paintings.

THE PROCESS

• Fill little jars or a plastic egg carton with some liquid watercolors. Sometimes I add a splash of water to make a lighter color.

• Have the children put the cotton swabs in as they sit down because the cotton swabs will expand during use (be sure to have extra ones handy).

• The children can paint any way they wish, making sure to put each cotton swab back in its correct color.

OBSERVATIONS

The children started out by just putting a bit of each color on their paper in little dots. They were testing and learning their medium. Soon they discovered lines, circles, and blending colors. I gave them many pieces of paper so that they could keep trying new techniques. I encouraged them to fill in all of the white space. Some children really feel compelled to mix up the cotton swabs and blend all their colors. Process art is all about discovery, and if mixing colors excites and interests your child, then let her explore!

Overheard:
"My Q-tip is not working anymore. But I can just use the other side!"
—Piper, age 5

VARIATIONS FOR NEXT TIME

• Use a larger piece of watercolor paper and draw a light grid with a pencil and ruler; the kids can fill in each square any way they please.

• Cut different shaped paper, such as circles, triangles, or long and skinny strips.

• Add some gold liquid watercolor to the palette, or let them squeeze some glitter glue onto their paper and use the cotton swab to blend it with the paint. Children love gold and glitter!

• Make the little paintings into a garland by punching holes in the top corners and stringing with yarn.

 Tip: *Often, when working on a small scale like in this workshop, I take the time to teach the children about color families. For instance, blue, green, and turquoise are in the same color family (blue + green = turquoise), and red, yellow, and orange are in the same color family (red + yellow = orange). When staying in the same color family, colors will always blend without getting muddy.*

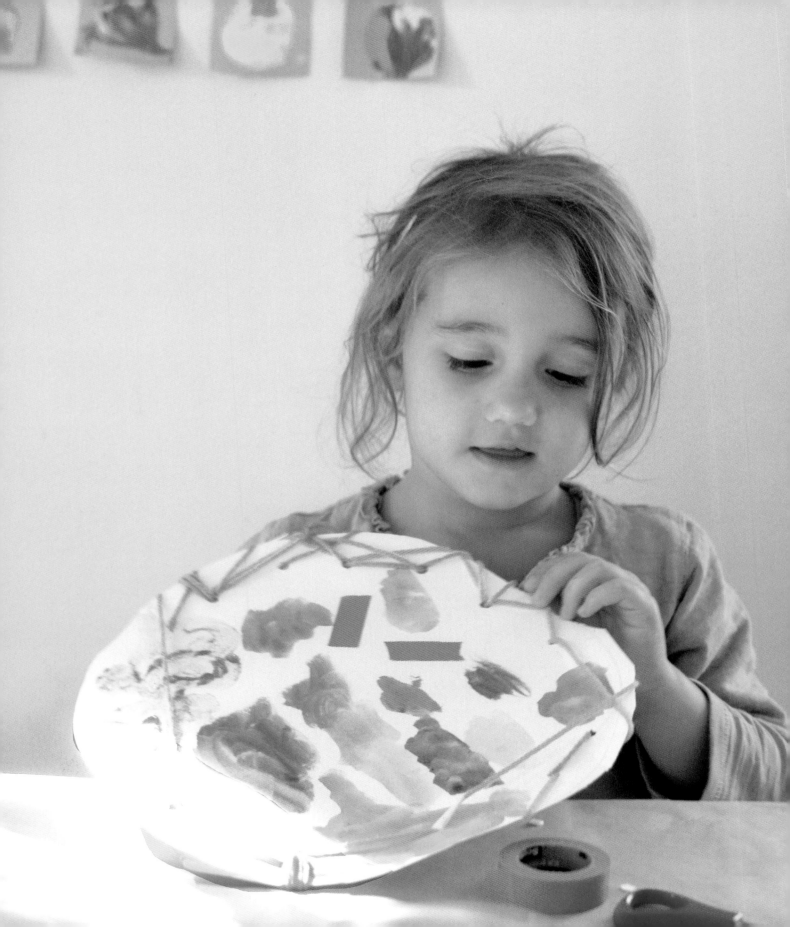

WATERCOLOR LACING CARDS

In this workshop, children explore the circle shape and learn the basics of sewing.

GATHER YOUR MATERIALS

- Watercolor paper
- Circle template, such as a bowl
- Pencil
- Watercolors
- Glass of water + brush
- Glitter glue
- Scissors
- Hole punch
- Yarn
- Washi tape

PREPARE YOUR SPACE

Find a large circle template, like a bowl, and use that to trace your circle onto the paper with a pencil. You can do this in preparation, or children can find their own bowl and trace their own circle. Put out the paints, water, and glitter glue first. Have the other supplies ready on a shelf or a tray. There is no mess, so you don't need to cover your table.

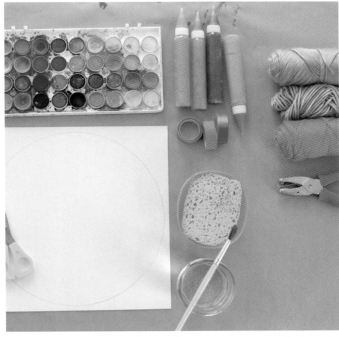
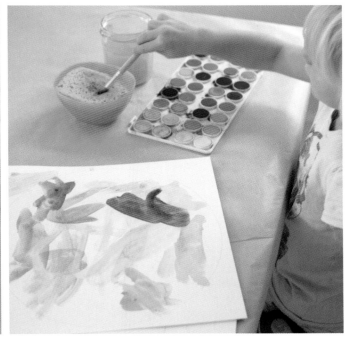

Children use critical thinking skills to lace yarn around a big circle.

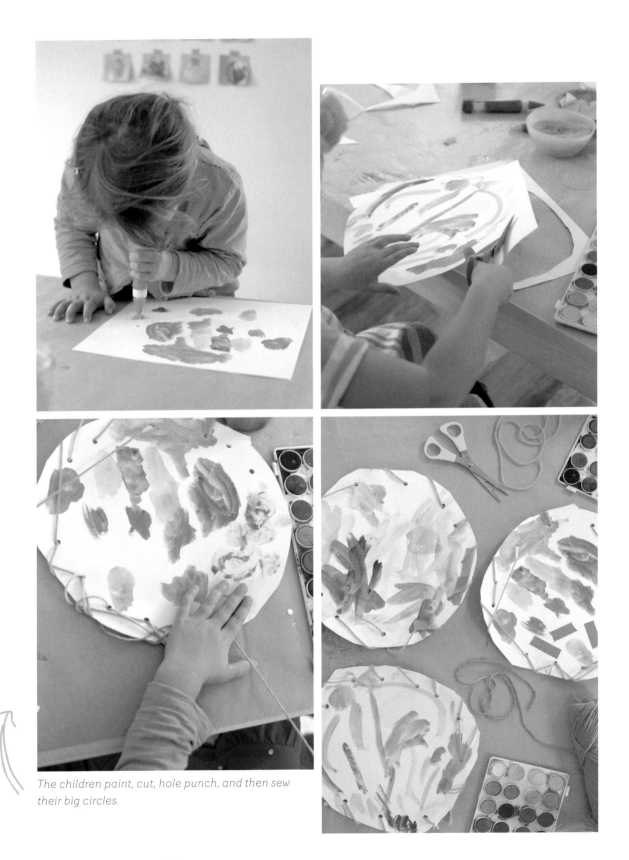

The children paint, cut, hole punch, and then sew their big circles.

THE PROCESS

- This workshop begins with a simple invitation to paint. I traced a large circle onto a piece of watercolor paper (you could do this together with your child, searching your home for a big circle shape) and put out some paints and glitter glue, and the children just began to paint.

- When I noticed that they were coming to the end of their painting, I brought out a tray with the scissors, hole punches, yarn, and washi tape.

- They cut out their circles, and then we talked about the words *sewing* and *lacing*. It turned out that one of the children had a grandma who sewed, which was great because she was able to make a connection, and also because her excitement was infectious!

- Next, I asked the question, "How can we use these supplies to sew this yarn around our circles?" Children are very resourceful and clever. They figured out that they could use the hole punch to make holes. We cut a length of string together, and I added a little bit of tape at the ends so it worked more like a shoelace. This helped them with lacing through the small holes. You could also just use a larger hole punch (we used a ⅛-inch [3 mm] hole punch, but a ¼-inch [6 mm] punch would be easier).

OBSERVATIONS

Some days in art class, my workshops are very open-ended and child-driven, where there doesn't need to be any explaining or instructions. I call these "invitations" because the setup is enticing and it provokes their imagination. On other days, I teach a skill. In this workshop, I introduced the idea of sewing. If you haven't sewn before, don't be intimidated. It's much like lacing a shoe. You just go in and out of the holes. There doesn't need to be any consistent stitch, the children just find a hole (even if it's across the other side of the circle) and practice going in and out. What I love about teaching a skill is that they can bring this new knowledge to future creations. Now they will have another way to express themselves, in the language of sewing!

Overheard:
"I used my mouth to squeeze the glue because it was stuck."
—Lucy, age 4

VARIATIONS FOR NEXT TIME

- Draw other large shapes to paint and sew, like triangles, hearts, or diamonds.

- Instead of paint, the children can use markers and crayons to color in their shape.

- Use paper plates instead of watercolor paper.

- For a larger group, the children can use their problem-solving skills to figure out how to sew all of the shapes together.

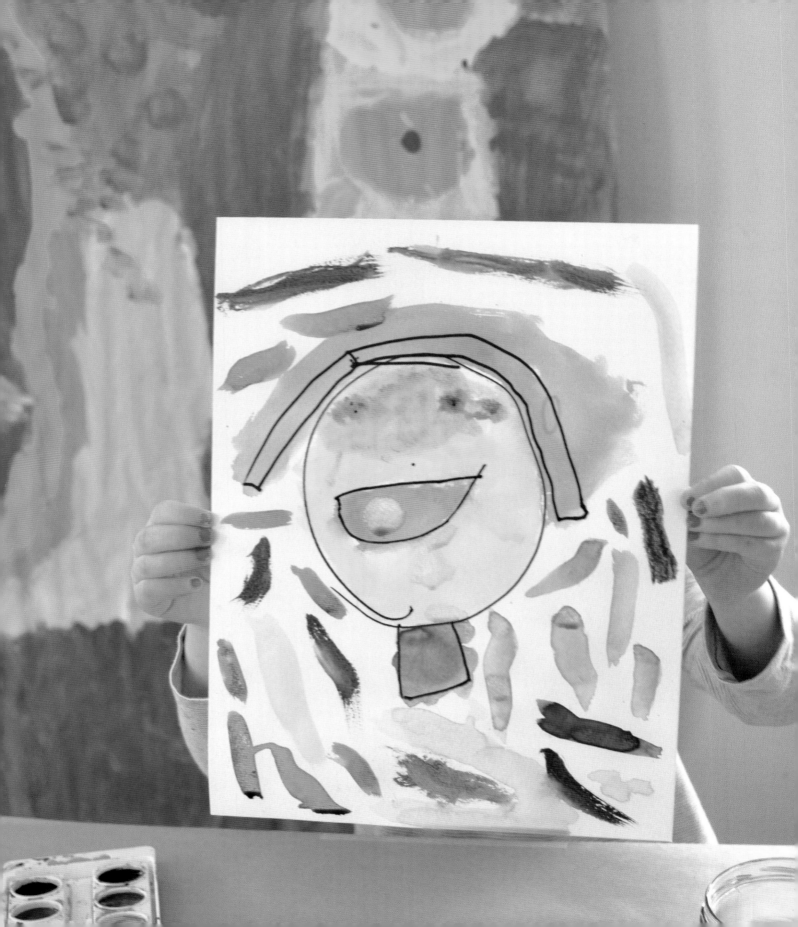

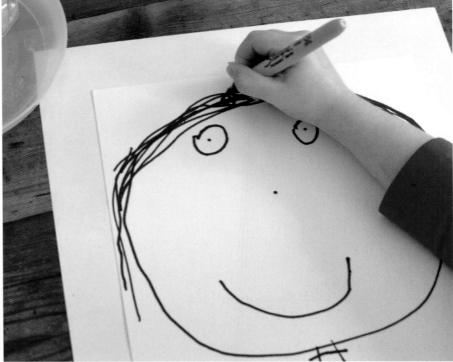

Workshop 6

SELF-PORTRAITS

How does it feel to be you? In this workshop, the children express through their art how it feels to be them.

GATHER YOUR MATERIALS

- Watercolor paper (9 x 12 inches [23 x 30.5 cm])
- Watercolors
- Glass of water
- Paintbrush
- Damp sponge or paper towel
- Black permanent marker (such as a Sharpie)

PREPARE YOUR SPACE

Watercolors are not messy, so you don't need to cover your table. Sometimes I tape the paper onto a piece or newspaper or scrap paper that is a little bigger; this prevents any paint mess. Fill a glass with water and provide a piece of paper towel or damp sponge for dabbing the brush in between colors.

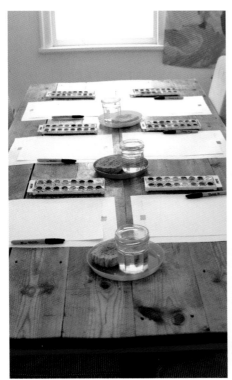

The children draw themselves after being asked, "How does it feel to be you?"

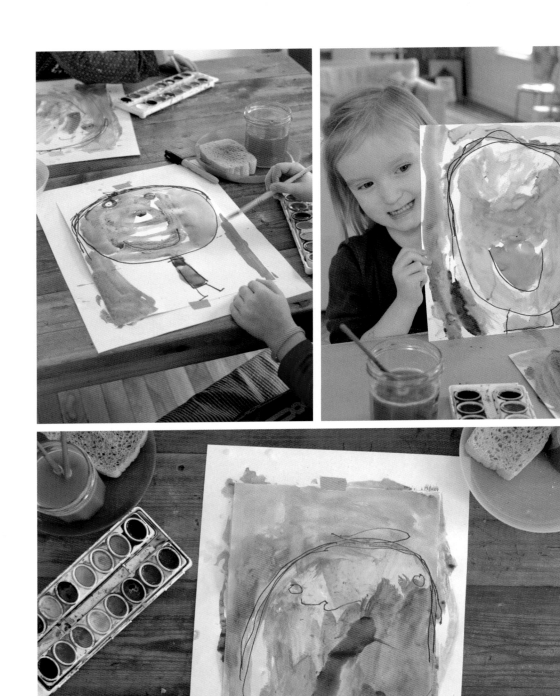

When the children are ready to share their work, it is a wonderful opportunity to connect with them and talk about their feelings.

THE PROCESS

- Ask your child, "How does it feel to be you?" Let them think and contemplate for as long as they need to. They will start to draw and paint when they are ready.

- Remember, this workshop is an invitation to paint from a deeper place. Your child will have a moment of self-reflection. There is no right or wrong. When your child is ready to share their work with you, it will be a wonderful way to connect with them and talk about their feelings.

OBSERVATIONS

I heard a speaker once tell about the small things he does to connect with his daughter after a busy week of work. On Saturdays, he takes his daughter to the coffee shop and they share a treat. Over this meal he asks her, "How does it feel to be you?" What a wonderful way to start a conversation! In art class, I used this question as a provocation. The children have all drawn themselves before, as the face is something we revisit often. But this time I did not bring out any mirrors because I wanted the workshop to be more about how the children were feeling, rather than how they looked. As I observed the children working, I noticed that their choice of color and their strokes said more about how they felt than what their final picture looked like. One child "danced" her brush across the page, while another painted over the same spot with every color. I am not an art therapist, but I could see how this workshop helped the children express their feelings and connect with one another.

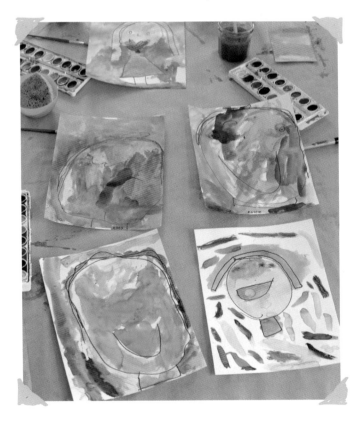

VARIATIONS FOR NEXT TIME

- Collage would be another wonderful medium to use when creating these self-portraits. Set out bits of paper that the children can cut or tear, and some glue.

- Change up the paper size, from very small to very large. Children are motivated by anything different.

- Use crayons first, then watercolor on top. This is called crayon resist. (See this technique on page 37.)

TIME AND CLOSE ATTENTION: REFLECTIONS ON REGGIO EMILIA'S 100 LANGUAGES OF CHILDREN

100 LANGUAGES OF CHILDREN (excerpt)

The hundred is there.
The child
is made of one hundred.
The child has
a hundred languages
a hundred hands
a hundred thoughts
a hundred ways of thinking
of playing, of speaking

—LORIS MALAGUZZI, FOUNDER, REGGIO EMILIA PRESCHOOLS

The late founder of the Reggio Emilia approach, Loris Malaguzzi, revolutionized the image of the young child. He spoke about the 100 languages of children and the image of the child being capable, competent, and full of potential.

Every child is capable. Every child is competent. This I believe. As adults, it is our responsibility to help our children gain a better understanding of who they are in relation to their surroundings. We must help draw attention to and place value on the unique way in which each child views his or her ever-changing world. In schools we place emphasis on the spoken and written language to express our ideas, yet we must not limit children to these two forms of expression. We must provide additional experiences that inspire children to communicate their thoughts and ideas through their 98 other languages.

The creative process invites children to explore their own 100 languages without barriers, without boundaries, and without guidelines. Materials and experiences can help access, uncover, and support the 100 languages that children utilize to express their understanding of self. A spool of wire, a bag of clay, an array of paint jars, a dance across the room, a

musical note sung out loud . . . these are some of the many different languages that invite self-expression through the creative process.

As a parent, my travels to the schools in Reggio Emilia, Italy, were life changing. I began not only to listen carefully to what my children were saying but also to notice how they were choosing to spend their time. What were their interests and how did they interpret their world? I gained a new appreciation for the way in which our living space encouraged exploration. I was determined to prepare a home environment that spoke their 100 languages. To do so, this required two things: noticing, and then action.

Noticing

My daughter, the behaviorist: a keen observer of people's interactions, gestures, and relationships. She needed opportunities to try on and act out many different ways to be in this world.

Action

We intentionally had a busy house with friends and family buzzing around, engaging in social experiences: cooking for a bake sale, preparing for the theater show, drumming up action in the neighborhood, organizing family outings, and taking frequent trips to New York City.

Noticing

My son, the naturalist: passionate about the outdoor world and especially our pond. He needed hours of outdoor exploration, as well as ways to bring the outdoor world inside.

Action

We gathered rocks, minerals, bark, leaves, books, magazines, and videos. We created habitats for living creatures, including salamanders, toads, frogs, birds, and iguanas. We visited nature centers, museums, and science labs for inspiration.

Noticing

My son, the collector: deeply focused on the facts of his baseball, football, and Pokémon cards along with the character details of his action figures. He needed to create systems for his cards, tally sheets for his statistics, and space for his dramatic play.

Action

We saved boxes, wooden blocks, sticks, stones, and fabric for the elaborate fantastical settings that brought his figures to life. We had large chalkboard and multiple oversized charts to record updated stats and a trunk to store boxes of figures and cards. In addition to reviewing magazines and newspapers, we attended sporting events and visited collectors' shops to spend the pennies he'd saved.

I was challenged to think further about how our home could cultivate and foster these (and other emerging!) interests and the materials and experiences I needed to provide. How could our home offer opportunities for each child to find, utilize, and express the 100 languages? Together, we created a studio-like space with paint, yarn, fabric, glue, scissors, paper, cardboard, magnifying glass, mini aquarium, mirror, topic-related books, empty boxes, plastic jars, and so much more.

I realized that the 100 languages would emerge if we could do the following:

- Take a closer look . . . Really take a closer look.
- Let ideas emerge (you can't force them).
- Explore materials (authentic materials).
- Let new ideas emerge and let discovery happen.
- Pose questions.
- Develop theories, and challenge theories.
- Allow new interests to be discovered.

As for my children, twenty years later:

- My behaviorist daughter holds a degree with a specialization in anthropology and did her graduate work in social services. She has been exploring her passion and purpose through advocacy in the field of social work.
- My naturalist son earned a degree with a specialization in environmental science and is exploring his passion and purpose through food, agriculture, and photojournalism.

- My collector son graduated with a degree that specializes in creative writing. He is a sports journalist, exploring his passion and purpose through creative writing and reporting on sports statistics and stories.

It makes my heart sing to know that each one is fulfilled, inspired, and doing authentic work . . . go figure.

—*Betsy McKenna*

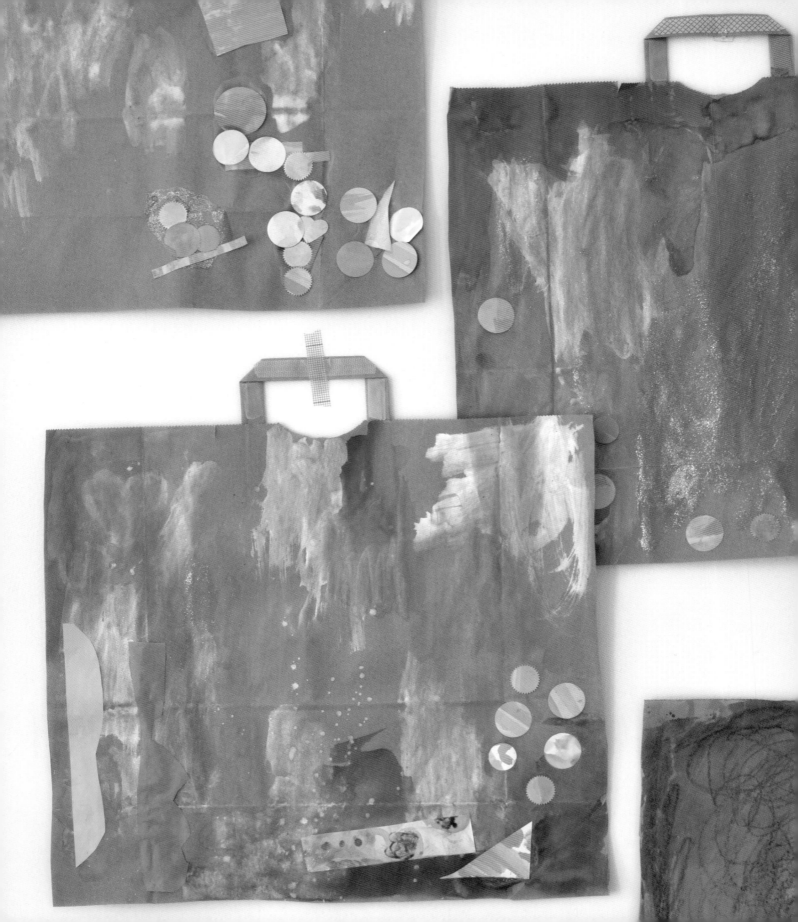

PAPER BAG COLLAGE PAINTING

I love recycling brown paper shopping bags as a material for art class. Not just because they are free and I have so many of them, but also because they come with a built-in handle!

GATHER YOUR MATERIALS

- Brown paper bag
- Scissors
- Watercolor paints
- Glass of water
- Paintbrush
- Collage materials
- White glue and/or glitter glue
- Washi tape (optional)

PREPARE YOUR SPACE

This workshop is not too messy. If your table is not precious, then you don't need to cover it. Otherwise, cover your table with some newspaper. Cut up your paper bag by cutting down the sides, then cutting off the bottom. You will have two halves. If you have been collecting collage bits, gather them into a basket or tray, or just set out the watercolors and some crayons!

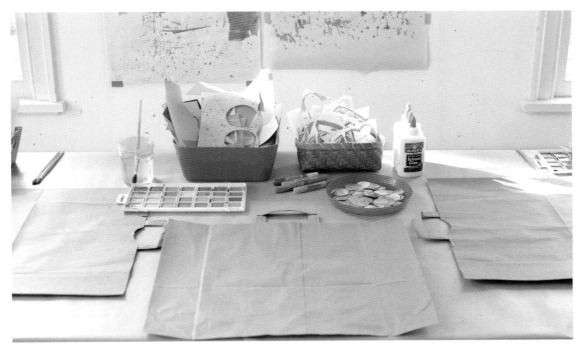

Brown paper bags are a perfect recycled material because they have a handle!

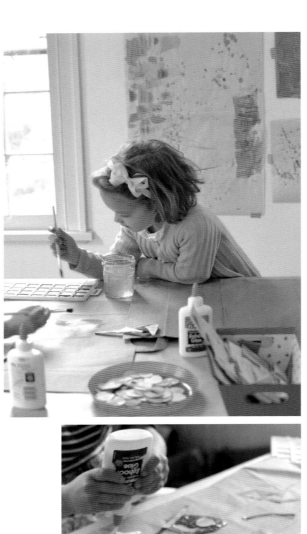

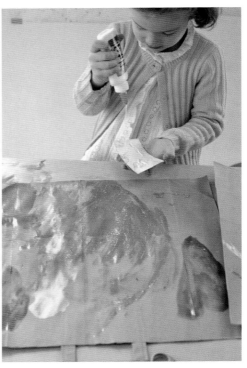

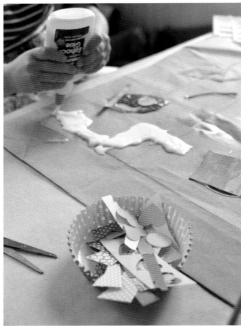

In this open-ended workshop, children are allowed to freely explore their materials and express themselves in their own way.

THE PROCESS

- Let the children explore their materials. They can choose to start painting or start collaging. Or they can go back and forth. This is an open-ended workshop whereby each child will express him or herself in a different way. There is no right or wrong.

- Some of our collage materials are small circle and heart cutouts. If you're wondering about these, I have a set of paper punches that the kids often use. We collect these bits and use them in collage work. Sometimes we also cut up old artwork, paint chips from the paint store, and cupcake liners.

- On this day the children used a special set of iridescent watercolors that I purchased. But we have done this workshop many times and regular watercolors work wonderfully!

- When they have finished their collage and painting, they can embellish the handles with some washi tape.

Overheard:

"I'm putting glue on top of my glue. I'm squeezing really strong."

—Madsie, age 6

OBSERVATIONS

When children are allowed to explore their materials freely, they become more engaged and invested in their work because it is theirs and they have nobody to please. Without limitations or any preconceived ideas, children will use their imagination to make art that is meaningful and exciting to them. Through this exploration, they are discovering how materials work, and learning to tell their own story. They build on their knowledge and make their next decisions based on experience. They delight in their own good ideas and build their confidence in taking risks. All of this is important in shaping their sense of self.

VARIATIONS FOR NEXT TIME

- Use crayons or oil pastels with watercolors for a "resist" technique (like we did in the workshop on page 37).

- Use chalk with watercolors. Draw on the wet watercolors for a more vibrant chalk color.

- Collage with fabric scraps, yarn, and other textiles for a more textured look.

- Make self-portraits with markers and watercolor.

- Use letter stencils to trace the child's name onto the artwork.

- When their paintings are fully dry, children can use the washi tape to embellish more than just the handles—they can use it to add to their paintings. Sometimes I bring out washi tape as a part two (see page 47).

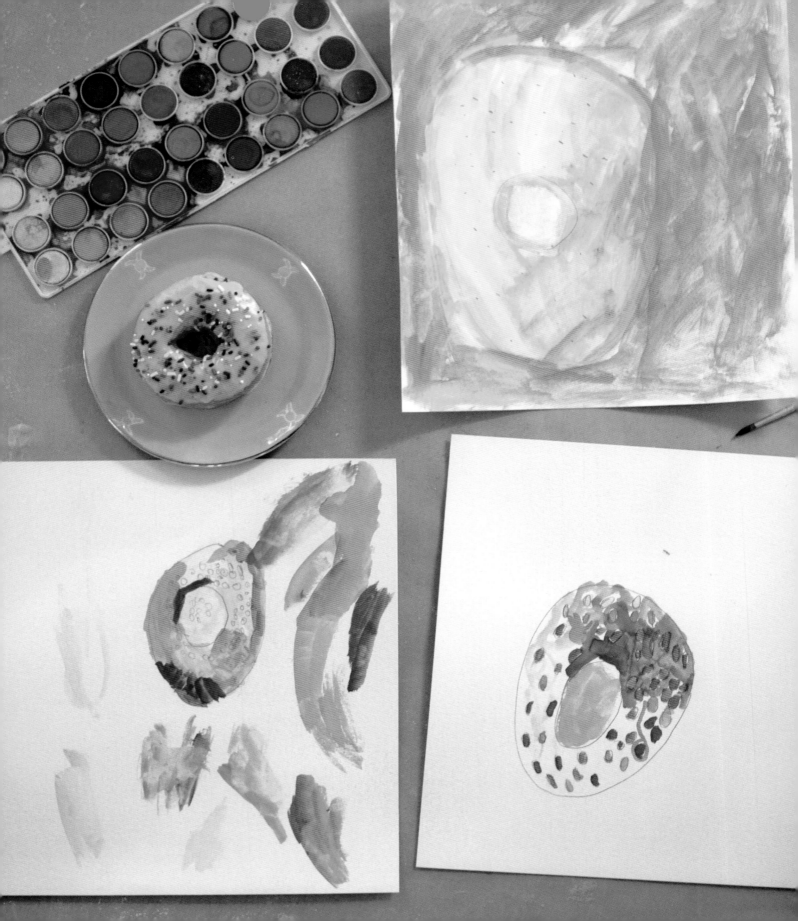

STILL LIFE with DOUGHNUT

A still life is a drawing or a painting of an object or a group of objects that is close to you and doesn't move. For children, it is a wonderful way to work on observing details. In this workshop, I used a doughnut for its simple shape, bright colors, and yummy deliciousness.

GATHER YOUR MATERIALS

- Still life object
- Pencil
- Watercolor paper
- Watercolors
- Brushes
- Glass of water
- Damp sponge

PREPARE YOUR SPACE

Watercolors are not messy, so there is really no need to cover the table. Choose a place with good lighting and be willing to leave the still life there for a day or two, inviting all the artists in the family to give it a go.

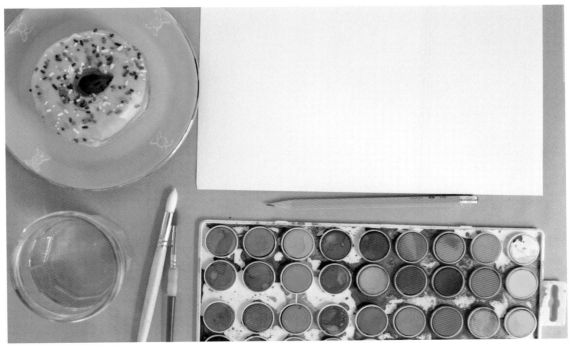

Doughnuts are colorful and have a familiar shape, which makes the still life very inviting.

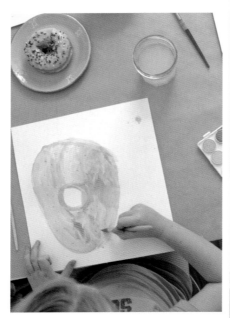

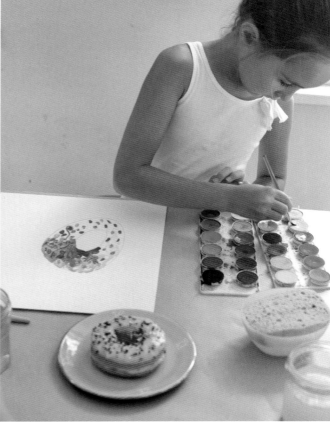

Still lives are a wonderful way for children to work on their skills of observation and drawing.

THE PROCESS

After setting up your still life in an inviting way, it is now time to let your child observe, draw, and paint. As the adult, place no emphasis on outcome, just let things be and trust that your child has a unique way of seeing things. There is no right or wrong.

OBSERVATIONS

It's funny that this heading is "observations," because that is exactly what the children are doing when they set about drawing and painting a still life. Doughnuts can look a whole lot of ways, and I really loved watching each child's interpretation of what he or she was seeing. Some doughnuts were big and filled the whole page; some were small with detailed sprinkles. Some children moved quickly; others took their time. Careful observation of what lies in front of you is an important skill to develop in both art and life. Learning to take your time to look—really look—is something new for young children. As always, they will rise to the occasion. Remember that children see things very differently than adults do. Give them space to express their own ideas. Knowing their artistic interpretations will always be respected and celebrated, they will happily continue to explore their creativity.

VARIATIONS FOR NEXT TIME

- Other still life ideas of familiar objects: a vase of flowers or just one flower, some fruit either on its own or in a bunch (apples, pears, bananas, and strawberries are good fruits to try), a cake or cupcake, gumballs in a bowl or jar.
- Let children draw their lovey or favorite toy.
- Let them create something with play dough and then draw it as a still life. This could be a more abstract still life.
- Another way to encourage observation and drawing skills is to take it outside to do some landscape and nature drawings.

> **Overheard:**
> "When can we eat the doughnut? I really want to eat it."
> —Annie, age 6

Tip: *When using palette watercolors, which are very dry, I tell the children to get their brush full of water, and then swirl the color while counting to twenty. This way they will get a nice, vibrant color instead of a very light color. They know this technique so well that each time we use these watercolors, I have a room full of children counting to themselves. For younger children, this is a great way to practice their counting!*

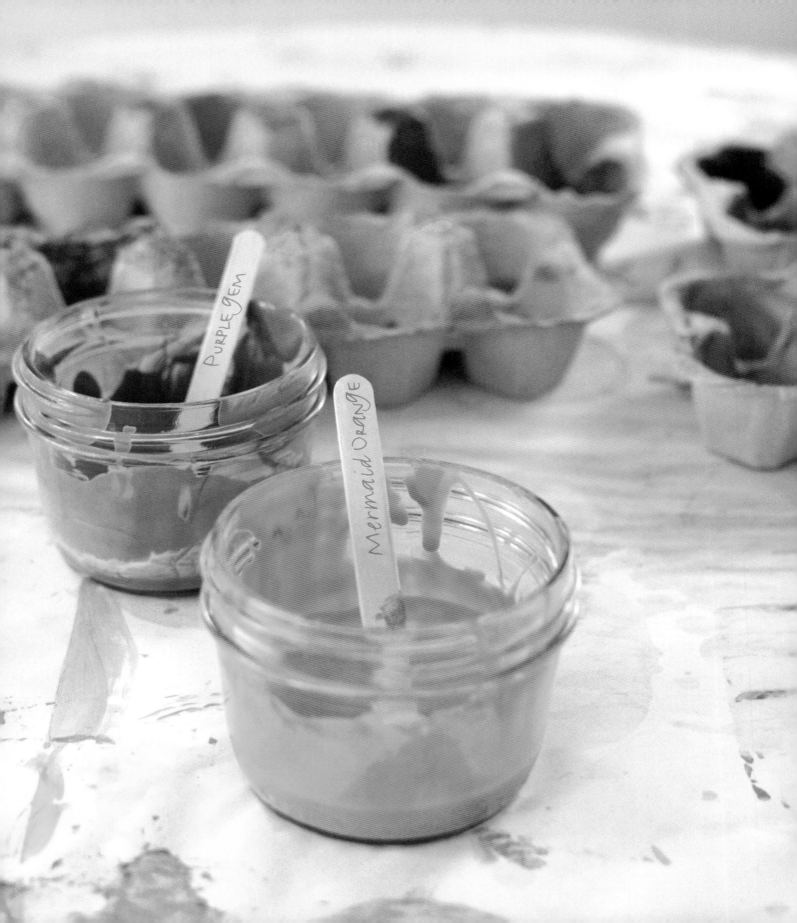

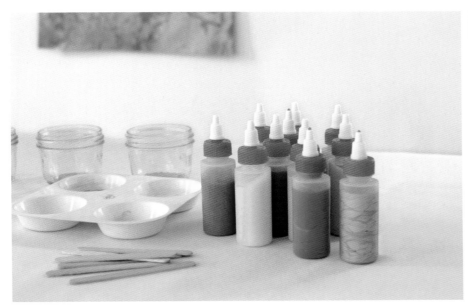

Workshop 9

MIX YOUR OWN PAINT COLORS

Each week in art class, the children see me popping into my back-room office to get more materials here and there. They often follow me in to stare at my shelves of supplies, especially intrigued by the paints. Their interest and inquiries led me to this Reggio-inspired paint-mixing workshop.

GATHER YOUR MATERIALS

- Tempera paint
- Small bowls or jars for mixing
- Small squeeze bottles (optional)
- Plastic knives, spoons, or Popsicle sticks
- Paper
- Brushes
- Glass of water
- Damp sponge

PREPARE YOUR SPACE

Cover your table with newspaper. Gather a bunch of jars and containers so the children have an opportunity to mix several different colors. I transferred some primary colors to smaller squeeze bottles for their little hands, but you don't have to do this. Have paper and brushes ready to go, but set aside.

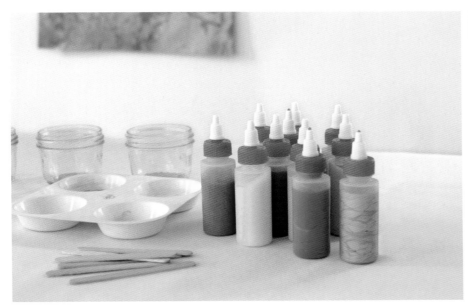
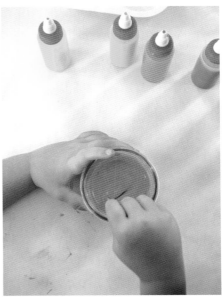

The children squeeze paint and watch the colors blend as they mix them together into new colors.

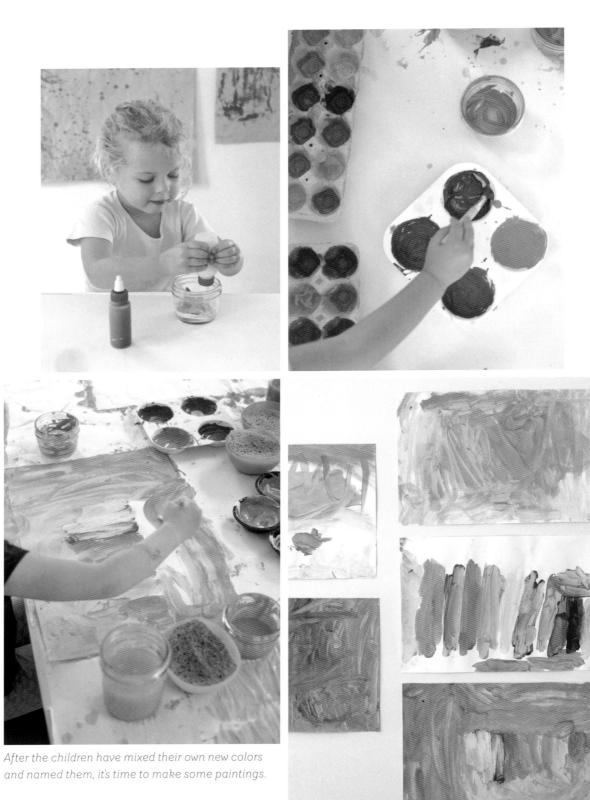

After the children have mixed their own new colors
and named them, it's time to make some paintings.

THE PROCESS

- To begin, I transferred some paint from the big bottles to some little squeeze bottles. If you don't have these, then either let your child squeeze from the big bottles, or you could transfer the paint into some jars and the children can use spoons to scoop out their colors.

- For this workshop, we worked with basic primary colors: blue, red, and yellow. The children requested pink and gold, so I put those out, too. Color mixing for beginners should always start with the primaries, because from there the children will discover how to make all the secondary colors: green, orange, and purple.

- When they were satisfied with their new color, I asked each child to give it a name. This is an especially important step because it invites more self-expression.

- The children made paintings with their new colors, and one child had an idea to also paint egg cartons. We decided later to call the egg cartons "collectors," and they brought them home to collect little things.

OBSERVATIONS

The children often ask me about the rows of paints that I keep organized in my office. They ask questions like, "Why do you have so many paints?" "How does the paint get in there?" and, "Can we mix paints?" I decided they needed to make some discoveries for themselves. As the children approached this workshop, they were initially careful in their squeezing and mixing. But soon they were up on their knees, using more of their bodies and really getting comfortable with the idea of creating new colors. If you listen carefully to your children, their questions will lead you to creating workshops around their interests.

Overheard:

"I squeezed a tiny dot."

"Mine is making green."

"Can I use all the colors?"

"What will happen if I put pink in?"

"It's brown!"

"Mine is mermaid color."

"I'm making a gem color."

"What is your color called?"

"I don't know my color."

"Mine is called butterfly."

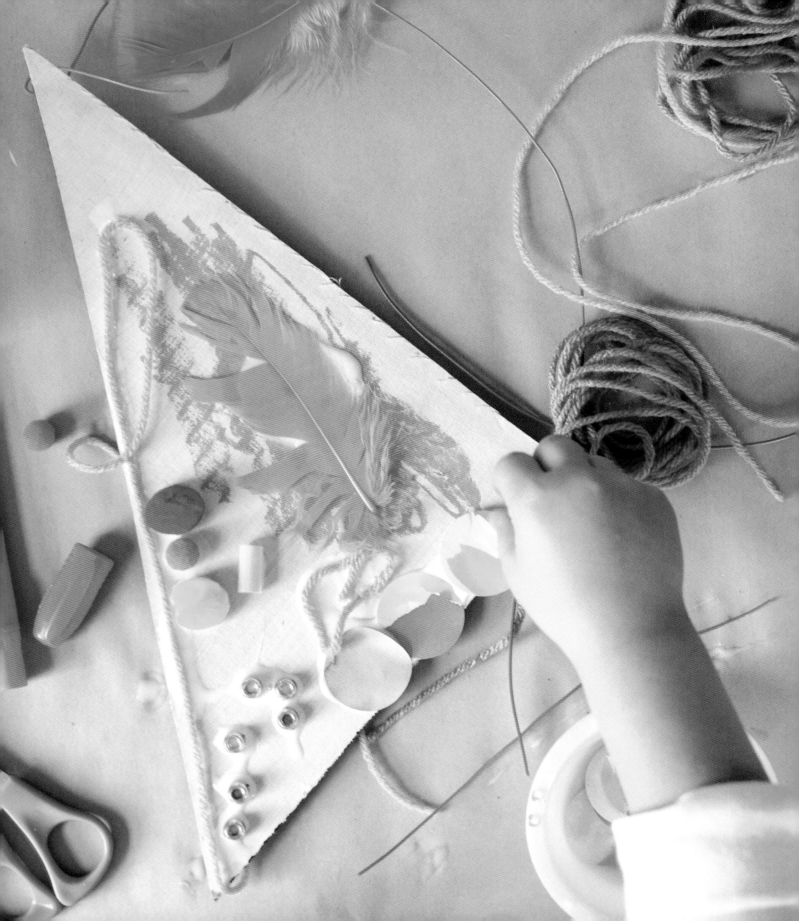

→ Chapter 3

WORKSHOPS // More to Explore

"The whole culture is telling you to hurry, while art tells you to take your time. Always listen to the art."

—JUNO DIAZ

In this chapter, children build upon their painting knowledge as they learn new techniques, such as printmaking, collage, assemblage, and paper folding. There is a second list of art materials with some of my favorites. These seven art workshops are invitations for self-expression. The children are evaluating their choices as they work. They are considering composition and symmetry, and using embellishments to add "flair." No two pieces are alike. The work is inherently personal because they have the freedom to explore their creativity without expectations.

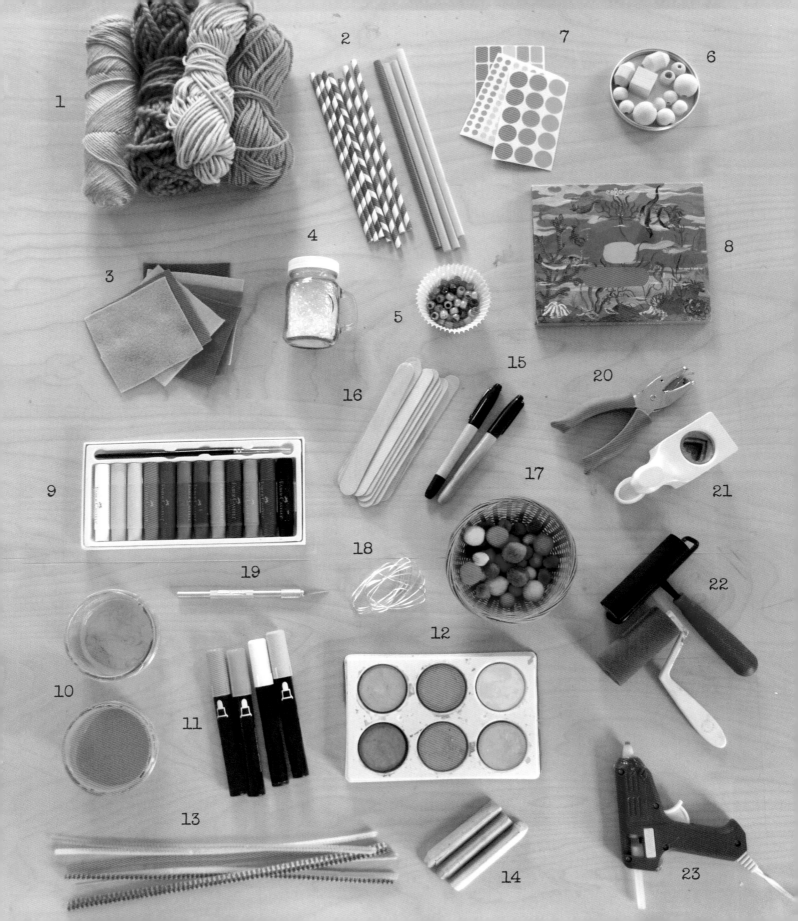

→ GATHERING MATERIALS

More Art Supplies

Here is a list of some colorful and versatile art supplies to add to your beginner collection. These materials are easy to put out on the table for open-ended exploration, and a wonderful way to enhance any workshop. I've also included a few extra tools that might come in handy. It's easy to find these supplies online or in local art and craft shops. All are nontoxic.

1. **Yarn.** I buy the very inexpensive kind at craft stores.

2. **Straws.** Either plain plastic or striped paper straws are fun for children to cut and use as beads.

3. **Felt.** Acrylic felt by the sheet can be found online and at craft stores.

4. **Glitter.** I buy the inexpensive kind that is not too fine and transfer them to salt shakers.

5. **Plastic beads.** We use pony beads, which are easy to handle for small fingers.

6. **Wooden beads.** We buy the natural kind and paint them with liquid watercolors.

7. **Sticker shapes.** Labels from an office supply store are perfect.

8. **Oil pastels.** Any inexpensive brand will do. They are softer and more vibrant than crayons and have the ability to blend. They do rub off on fingers, so keep that in mind.

9. **Gel sticks.** These are similar to oil pastels but are water-based, so you can use water and a paintbrush afterward to blend the colors. (These are made by Faber-Castell.)

10. **Tempera paint.** To add to your basics collection, get gold and fluorescents from the brand Sargent.

11. **Chalk markers.** These are opaque colors that draw like paint. Not just for chalkboards! Any brand will do.

12. **Fluorescent tempera cakes.** Use them like watercolors. (The brand is Sax.)

13. **Pipe cleaners.** Bead them, twist them, build with them, engineer with them. Many uses.

14. **Chalk.** Not just for chalkboards. These can also be used over wet watercolors (on watercolor paper).

15. **Black permanent markers.** These are not technically for children, since they are permanent, but they are the best to draw with before using paints because they won't run. Keep out of reach, though. (We use Sharpies. There are many brands.)

16. **Craft sticks.** Otherwise known as Popsicle sticks, these are a great extra material to have on hand.

17. **Pompoms.** Found at craft stores, pompoms are a wonderful, colorful, and whimsical addition to workshops.

18. **Craft wire.** Buy 18 gauge, which is easy to bend and shape, and great for three-dimensional art.

19. **Craft knife.** For grown-ups only! This tool helps when cutting cardboard, shoeboxes, and milk cartons. (X-Acto is a popular brand.)

20. **Hole punch.** I have both ¼ inch (6 mm) and ⅛ inch (3 mm). You can also buy a heart-shaped one!

21. **Paper punch.** We use these to cut larger circle and heart shapes.

22. **Rollers.** Another wonderful painting tool, rollers are great to use when printmaking.

23. **Glue gun.** A child as young as five can use a low-heat glue gun with the help of an adult.

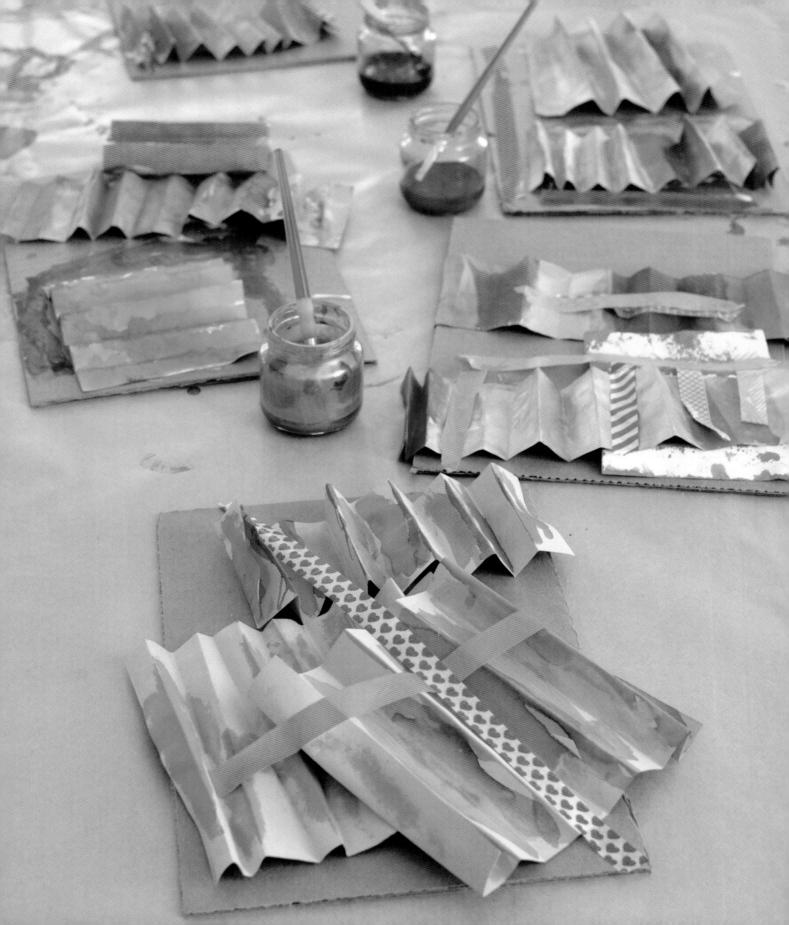

→ Workshop 10

FOLD and PAINT PAPER

One day in art class, the children were very interested in some pinwheels I had made for a family party. We decided to pull apart the pinwheel and see how it was made. This Reggio-inspired workshop emerged from the children's own exploration and ideas.

GATHER YOUR MATERIALS

- Sulphite paper
- Scissors
- Liquid watercolors
- Glass jars
- Brushes
- Paper towels
- Hair dryer (optional, to speed drying time)
- Small piece of cardboard
- White glue
- Colored tape

PREPARE YOUR SPACE

Cover the table with newspaper. Cut paper into several sizes of rectangles and squares, or let the children cut their own paper. Choose three or four paint colors and put them into the glass jars with a brush in each jar, or let the children do the choosing and gathering of materials.

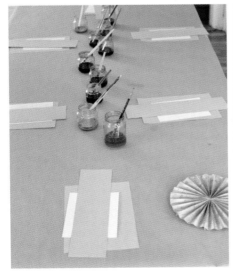
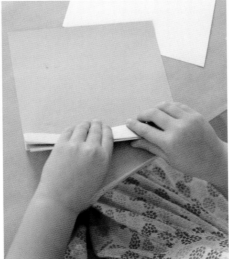
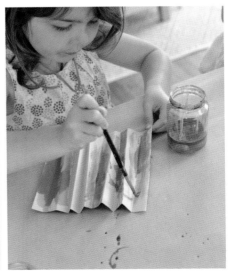

The children learn how to make accordion folds, then they explore painting with liquid watercolors.

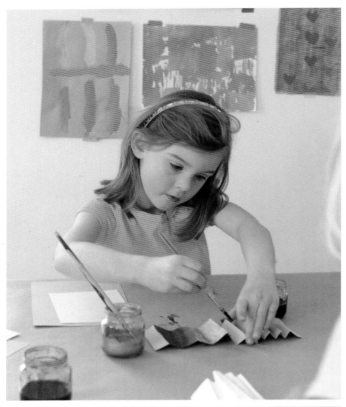

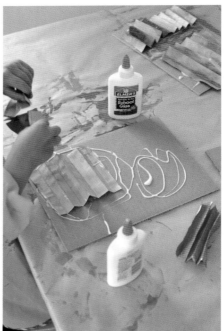

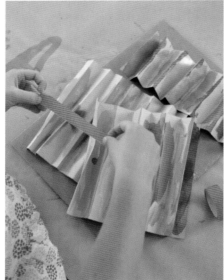

After painting their folded paper and letting their pieces dry, the children make three-dimensional collages with glue and colored tape.

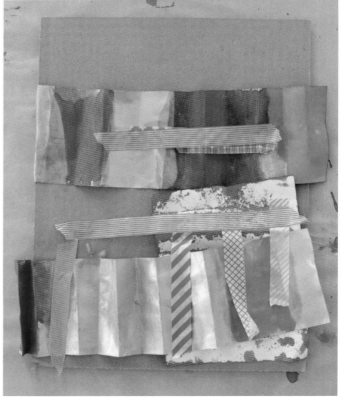

THE PROCESS

- To begin, I spent a few minutes teaching them the accordion-folding technique. The folds should go "back and forth" like a fan, not like a roll. It's amazing how quickly the children get the hang of this.

- When mistakes happen and their folds are all going in the same direction rather than back and forth, you could say, "I'm noticing that this folded paper stretches out like a fan, but this one is all rolled up. How do you think it got that way? Let's undo it and see how we can fold it differently."

- After they have folded a few, it's time to paint. If their folded paper gets very wet, they will notice the paper flattens out. This is a very interesting consequence that they can explore.

- In art class we sometimes use a hair dryer to speed along drying time. This is not only efficient, but it's also exciting and every child needs a turn. After drying, we noticed that some of the very wet paper was now almost flat again. Some of the children refolded their paper, and others left them flat.

- When their pieces were dry, I brought out some cardboard, tape, and glue. They were familiar with the materials and got busy right away gluing and taping their three-dimensional paintings.

OBSERVATIONS

As the creative process unfolded in this shared experience, it brought out the children's social nature. Learning from each other, they chatted about their ideas and interpretations. Listen carefully to what your children are saying and create a workshop around their interests.

Overheard:

"I have long paper."

"Mine is a fan."

"I want mine to be a fan, too."

"I'll show you, you just squeeze it like this."

"Whoa, look at this red. It looks like blood."

"Yuck! That's not nice."

"I have gold on mine."

"I want gold, too. Sam, can you pass the gold?"

"Mine are stairs."

"Mine are stairs to the sky."

"Mine are stairs to the moon."

→ Workshop 11

PLASTIC BAG MONOPRINTS

This workshop moves fast. Monoprints are very exciting for children because they get to make a twin image of their painting!

GATHER YOUR MATERIALS

- Sulphite or construction paper
- Plastic sandwich bags (heavyweight)
- Tempera paints
- Jars or containers for the paint
- Brushes
- Rollers (optional)
- Paper towels

PREPARE YOUR SPACE

Printmaking can get a bit messy. Cover your table with newspaper, and be sure to prepare a space on the floor or another table to dry the prints. Keep some paper towels handy to wipe hands and occasional rollers. Plastic bags can be reused by rinsing and drying. Prepare many pieces of paper, as things move fast!

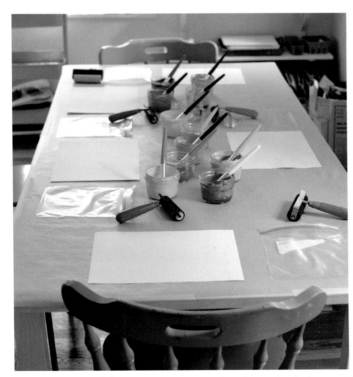

The children work fast to create monoprints from plastic bags and tempera paint.

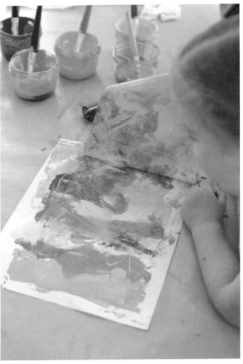

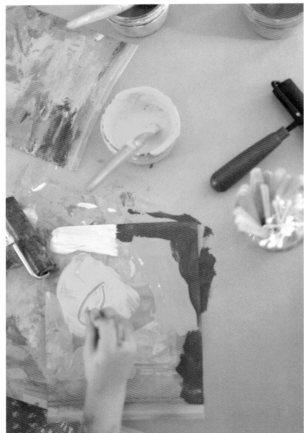

The children make design choices, like spacing, pattern, and balance, when creating their quiltlike collages.

THE PROCESS

- To begin, I talked to the children a little bit about printmaking, and what it means to make a print. Simply said, a print is a copy of your painting. There are lots of fancier words in printmaking, like image, ink, plate, and transfer. But with my four- and five-year-olds, I keep it really simple. We are making a twin!

- For this particular workshop, since I am teaching a skill, I demonstrate making a print. I don't draw anything; I keep it abstract and just put a few colors down on the plastic bag. I then show them how to lay the paper on top, and then use the roller (or your hands) to gently push down on the paper. Then I slowly lift up the paper and show them the twin image, which is always a magical moment.

- Let your children explore this new process. They will work at their own level and in their own style. Some children will copy just what you show them, and others will take risks immediately and try their own way of doing things.

- I put out some cotton swabs and craft sticks as drawing tools.

- The plastic bags can be painted over several times. In fact, some children printed over their prints once or twice. Or, you can rinse and dry the bags in between prints.

Overheard:

"Mine is not working.
I need more red."

—Sam, age 4

OBSERVATIONS

This type of printing, where your image is made just once (rather than a permanent image like a woodcut), is called a monoprint. Making monoprints is all about discovery. The children were learning as they worked, figuring out how to make the image they wanted and starting over when they needed to. They discovered that if you paint too thin, the paint won't transfer very well. Heavier paint made the best prints. They tried printing over their prints, using the rollers afterward on their prints, and drawing with the tools in front of them. This workshop was all about perseverance and problem solving, two very important life skills!

VARIATIONS FOR NEXT TIME

- Use very translucent paints (usually really cheap tempera paint is very translucent, and so are the neon temperas) and encourage your children to print over and on top of their prints to see the colors mix.

- Use white paint only on black paper.

- Practice writing and making letters. The children will discover what happens with words in printmaking! (Hint: They could make some secret messages with this writing.)

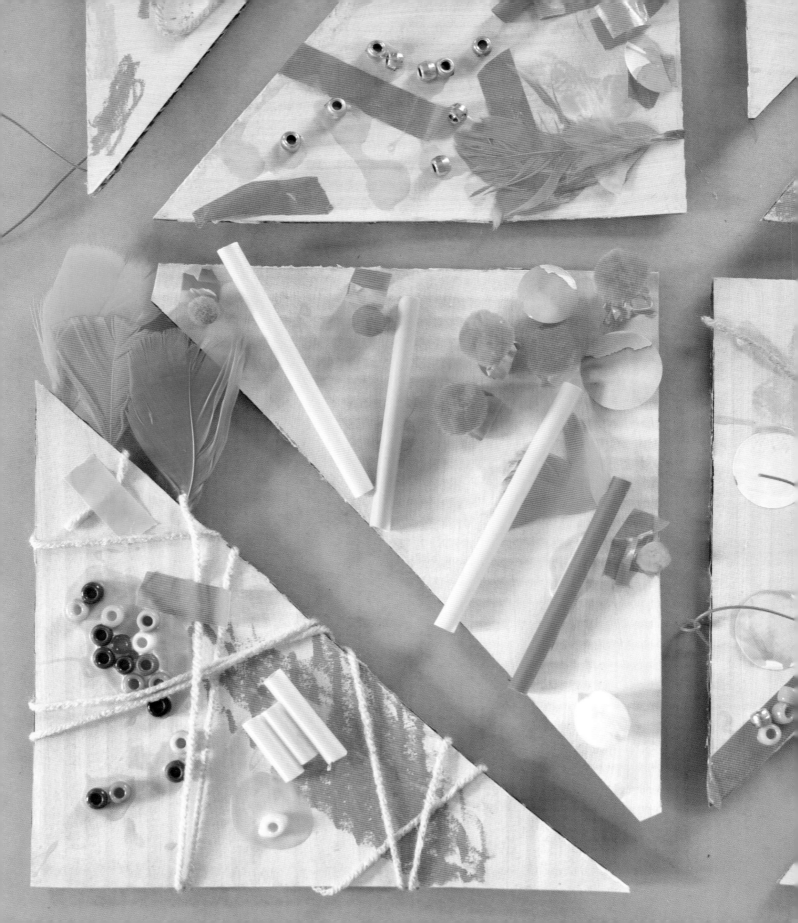

\Longrightarrow *Workshop 12*

TRIANGLE SHAPES ASSEMBLAGE

Assemblage is like collage, but it involves gathered or found pieces in a more active, three-dimensional way. Anything goes in this workshop!

GATHER YOUR MATERIALS

- Cardboard
- White paint (optional)
- Glue
- Scissors
- Colored tapes
- Ideas for materials tray: straws, feathers, beads, yarn, wire, collage bits, bottle caps, buttons

PREPARE YOUR SPACE

This workshop is not messy, other than a little glue spillage. You don't have to cover your table. Cut some triangles from cardboard. I put a coat of white tempera paint on them, but you don't have to. Gather as many little bits and pieces as you can and put them on a tray. Or better yet, you and your child can forage together to find just the right pieces for their art.

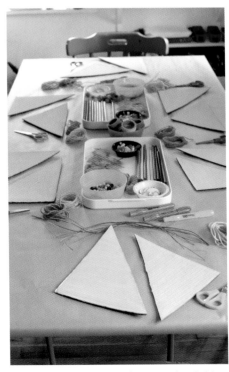 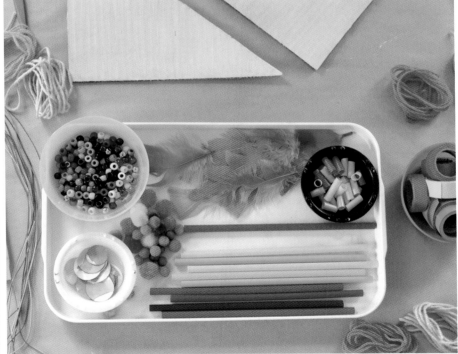

With an enticing tray of materials, children gather and assemble to make three-dimensional art.

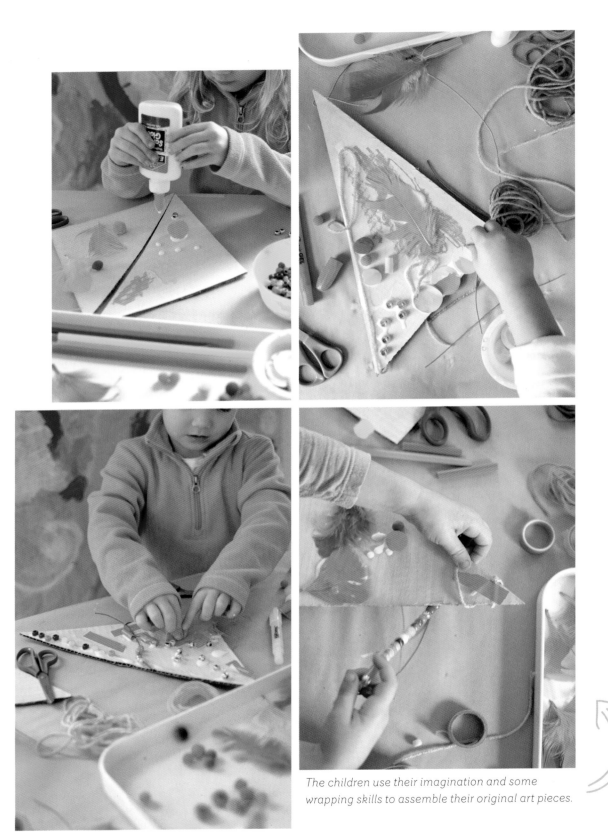

The children use their imagination and some wrapping skills to assemble their original art pieces.

THE PROCESS

- Putting together a materials tray (otherwise known as a tinker tray in my blogger world) is something I do often. It is an open invitation for your child to create. Select anything that you have available—it doesn't have to be fancy.

- Let the children just sit down and create from their own imagination. As in most of my workshops, there is no right or wrong.

- We have practiced wrapping yarn around things before, but if your child has never done this in the past, go ahead and show him. This skill will open up new possibilities for his creative expression.

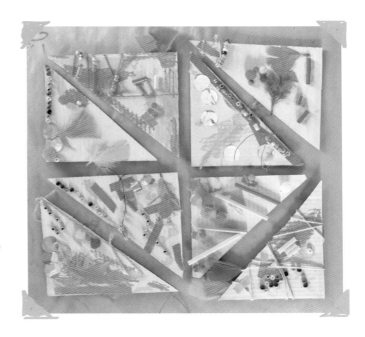

OBSERVATIONS

My art class is only an hour, so I almost always gather and set up materials before the children arrive. But this workshop would be a wonderful opportunity to collaborate with your child to gather and forage for materials together. This will give your child a voice in the process and empower her to take more risks in her art making. Children see things in such a different way than adults do. I can bet your child would find even more interesting materials to use, and use them in a way we might never imagine!

VARIATIONS FOR NEXT TIME

- This workshop would work well with any shape of cardboard. We have also done it with long rectangles and random shapes from the scrap basket.

- The children can paint their cardboard pieces, and then assemble their collages when dry on the next day.

- If you punch holes in the triangle shapes, you can attach them all together into a square (like the photo AT DIRECTION) with some wire.

- Go on a walk outside and find leaves, flowers, pinecones, and twigs to make nature-inspired assemblage art.

- Use these triangles as the sail of a sailboat, perhaps using an egg carton as the bottom of the boat.

Overheard:
"I'm scrunching my tape so it's sticky all around. And I need some glue also, to make it more stickier."
—Mason, age 4

MESS MAKING VS. MESSING ABOUT

"Believe me, my young friend, there is nothing—absolutely nothing— half so much worth doing as simply messing about in boats."

—KENNETH GRAHAME, *THE WIND IN THE WILLOWS*

When in your own childhood did you have the opportunity to mess about? Recall the sense of freedom that came with the experience. Remember the uninterrupted joy you experienced. Revisit the level of curiosity and the sense of confidence you gained from just messing about.

The messing about I remember for my children came with no instructions or directions on how or what to do. Messing about was simply a time for them to explore, wonder, be curious, and imagine all the possibilities.

When thinking about this idea in context of an art workshop, it is important to make the distinction between getting messy and messing about. It seems that art materials and art experiences are often categorized as getting messy. Yes, paint and glue can create a mess, but it's a kind of mess that can be easily cleaned. The adult's worry around a mess should not get in the way of providing opportunities for children to play with art materials. As adults, we can prepare the environment and protect the space by covering tables and putting the children in suitable clothing. With this in place, the children should be free to explore and create. So begins the messing about.

Children are innately curious and want to understand their place in the world. It is only through their senses that they can make this happen. Children need to touch, smell, taste, hear, and see the impact they have on their world. An aesthetic art experience is host to all of these possibilities. This is messing about.

Children need a place where they can use art materials to explore new ideas, discover something unexpected, and uncover yet another way to express their ideas. As adults, we do not need to get involved; in fact, all too often our good intentions become a source of interference. We just need to provide space and time for children to explore, ask questions, test ideas, and build their creative confidence.

Encourage messing about—let them try whatever moves them. Let them mess with materials and make a mess if that is part of their creative process.

After all, they can take care of just about anything with a little soapy water and a sponge.

—*Betsy McKenna*

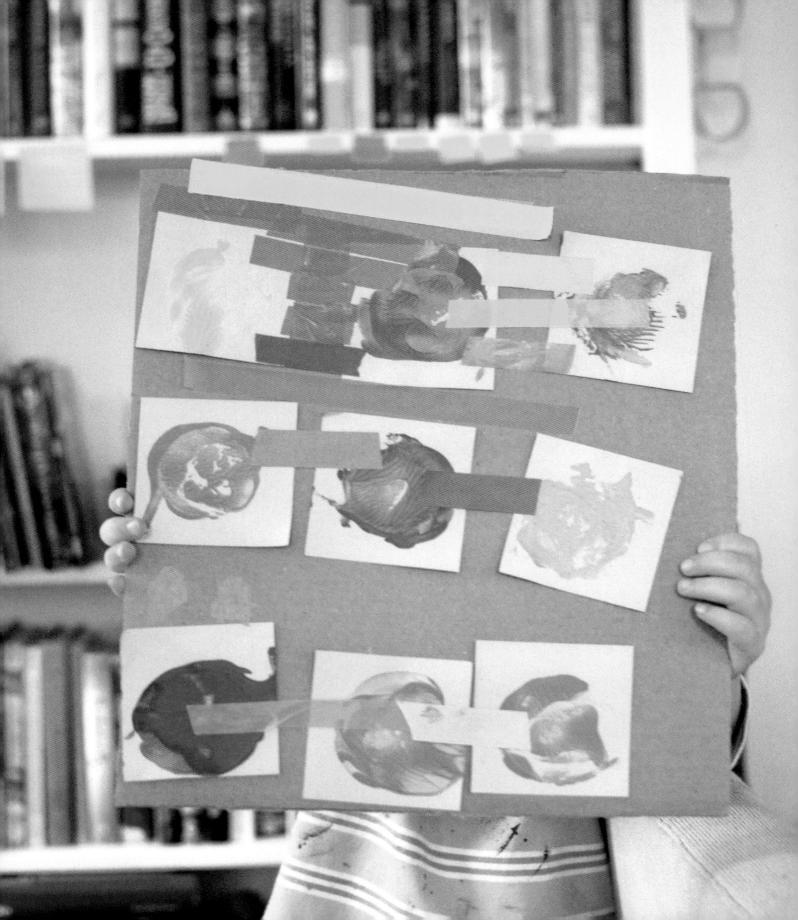

MUFFIN TIN PRINTS COLLAGE

In this workshop, a continuation from Workshop 2, the children use their muffin tin prints to create their own, unique patchwork collages.

GATHER YOUR MATERIALS

- Muffin tin prints (page 33)
- Cardboard
- Glue stick
- Colored tape
- Scissors
- Chalk markers
- Other collage materials (optional)

PREPARE YOUR SPACE

This workshop is not messy, so you don't need to cover your table. Just set out the materials and that's all you need to do!

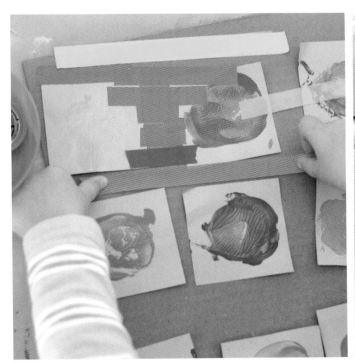
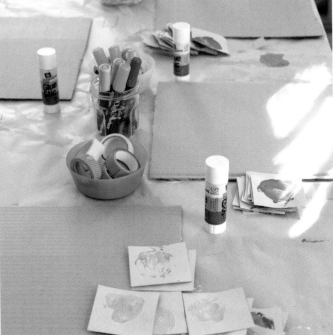

The children arrange their prints in a quilt-like way and use tape to add some more color.

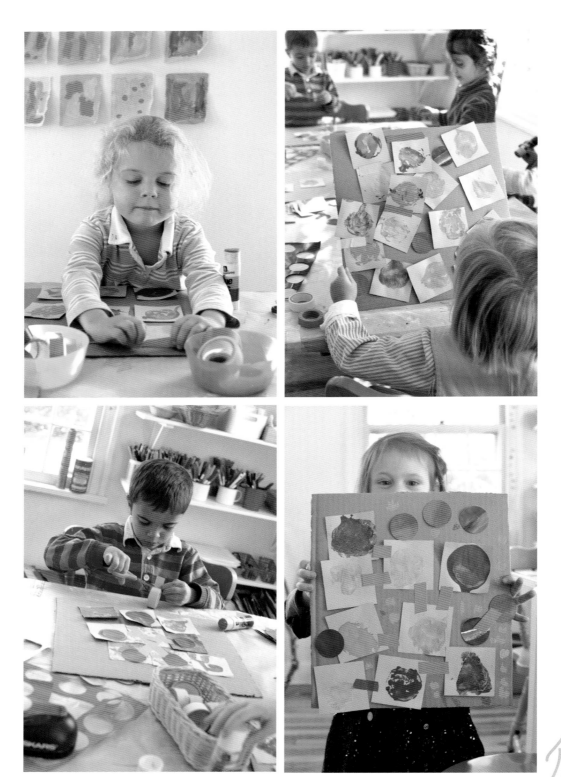

The children make design choices, like spacing, pattern, and balance, when creating their quilt-like collages.

THE PROCESS

- The children used their prints from the week before to make collages. They arranged their little squares in whatever way they pleased and used the other materials to embellish their designs.
- They used the glue stick first to attach their prints to the cardboard, then they used the tape to make things more secure and to add some color. The collage bits and chalk markers were available to add to their designs if they chose to do so.

OBSERVATIONS

This workshop is a wonderful way for children to explore the elements of design. In my humble opinion, I think young children, especially four-year-olds, have an innate sense of design. I never get tired of watching them work because they make choices that come from their heart, not from their brain. In making these collages, the children made choices about line, space, pattern, and even rhythm. I saw one child pick up her collage, move her eyes all the way around her artwork, put it down, and then reach for the yellow tape. She added one more piece of tape to balance out her design. It made my heart sing.

VARIATIONS FOR NEXT TIME

- We have made similar collages in the past with the small Q-tip paintings (page 43). You could use any small drawings or paintings to make this "quilt-like" collage.
- Use blank paper squares and have the children draw or paint on them afterward.
- Punch two holes on either side of the top and make a handle out of yarn or string or wire. The children can bead the handle if they want, or they can use the colored tape to wrap the handle.
- Bring out some white glue and some glitter. They can embellish some more, and you will make them very happy. Children love glitter!

Tip: *I am a quilter, and a quilt is very much like a collage. If you have any quilts in your house, or have access to quilts, show them to your children and talk about how the pieces all fit together to tell a story. This knowledge might help them approach their collages in a new way.*

Lucy L

ABBY

MASON

NEON RULER PAINTINGS

This simple workshop challenges the children to make lines with a ruler and a pencil. Then they use vibrant paint to add to their drawings.

GATHER YOUR MATERIALS

- Ruler or straightedge
- Pencil
- Paper (sulphite, construction, or watercolor)
- Neon tempera cakes or watercolors
- Glass of water
- Damp sponge or paper towel
- Brush

PREPARE YOUR SPACE

If you are worried about your table, you can cover it, but these water-based paints come off very easily and this isn't a very messy workshop. If you don't have a ruler or a straightedge, you can use a piece of cardboard, such as from a cereal box.

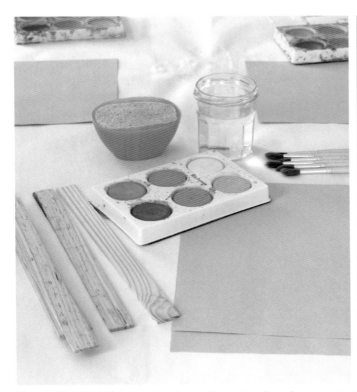
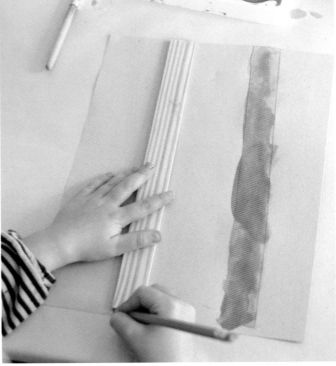

The children practice drawing lines with a ruler, then they paint with neon tempera cakes.

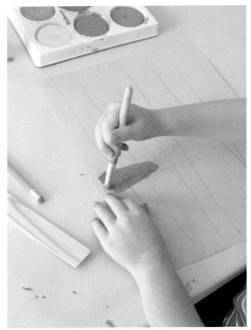

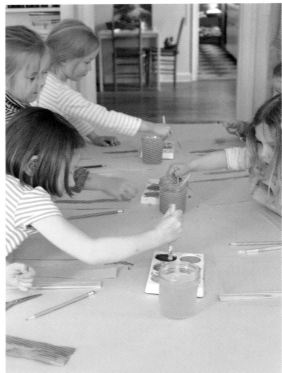

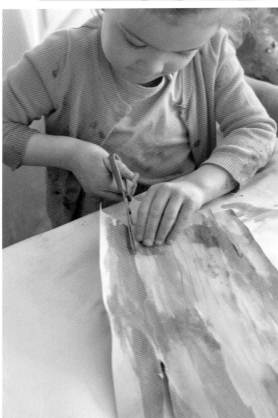

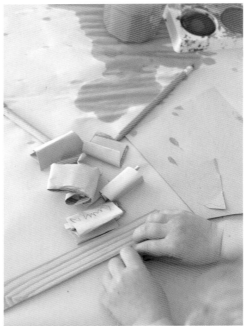

The children make choices about line and color and express their ideas with their friends.

THE PROCESS

- This invitation is so simple, yet the children always love seeing those rulers. Practicing to draw straight lines is a useful skill, but it is also fun!

- These photographs show the children using wooden paint stirrers because I couldn't find the rulers on this day. Genuine rulers provide another way to communicate ideas. Children will count out loud or use numbers in their conversation.

- When the children have finished drawing their lines, they can paint. I teach them to get their brush very wet, then swirl around on the color as they count to twenty. This will give them a nice, saturated hue. This works for the neon paints or any dry watercolor paints.

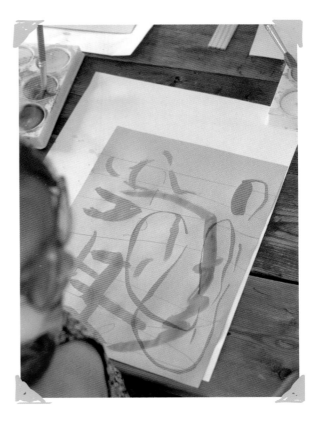

Overheard:
"I'm using the same color, but it looks different because I'm pressing gently."
—Caroline, age 5

OBSERVATIONS

Oh, how I loved watching each child interpret this workshop so differently! As one child drew straight lines and painted them in, another child wiggled the ruler and drew curvy lines, and another drew dotted lines and then mimicked those with her paint. When one decided to get some scissors off the shelf and cut her lines, several followed suit. One little artist even decided to roll her pieces up afterward, because why not? The children are free to make their own choices, which provide them opportunities to take risks and express their ideas. How wonderful it must feel for a child to have the confidence to express her intentions and then watch as her friends emulate her good idea.

VARIATIONS FOR NEXT TIME

- Change up the size of the paper to long and skinny, circles, or hearts.

- Add more mediums, like crayons, chalks, and markers.

- Teach your children how to draw a grid with the ruler, then they can paint in each square.

- Use a glass jar to trace circles on the page, then use the ruler to draw lines through the center of each circle to create snowflake-y designs.

POWERFUL PROMPTS:
BUILDING CREATIVE CONFIDENCE

It only takes a few words to influence a child's mind-set. It only takes a few words to build a child's creative confidence.

Why? Because children are capable! Children are competent! Every child has a unique level of creativity from within. Our role as parent or teacher is to mirror back children's own creative potential that they have not yet seen.

How can this be done? To start, we must see our role as a responsive facilitator, guide, and coach. This requires our being intentional about how we engage with the child. It involves being present and using just a few choice words. I have experienced firsthand the power of these prompts in both the classroom and the home. I have witnessed a transformation in the way in which a child sees him- or herself.

Below are some powerful prompts that can influence a child's positive mind-set and creative confidence:

I see that you . . .
"I see that you used red swirly lines"

Remind me how you . . .
"Remind me how to you made the paper stand straight up this way."

I know you can . . .
"I know you can figure this out. You have done it before."

Try it!
"Try it—you never know what might happen."

Take a chance . . .
"Take a chance, see what happens."

What do you think?
"What do you think about how to make your sculpture bigger?"

Give it a go.

 "Give it a go. That's the only way forward."

Tell me how . . .

 "Tell me how you built such a tall, sturdy structure."

You remembered how . . .

 "You remembered how to close the glue jar so it won't dry up."

I noticed that . . .

 "I noticed that you started folding the paper but then changed your mind and began to cut the paper instead."

Just try it and see how your child responds. I know you can because you would not be reading this essay if you weren't interested. I see that you're nearly done with the reading, and so now, give it a go and tell me what you think!

—*Betsy McKenna*

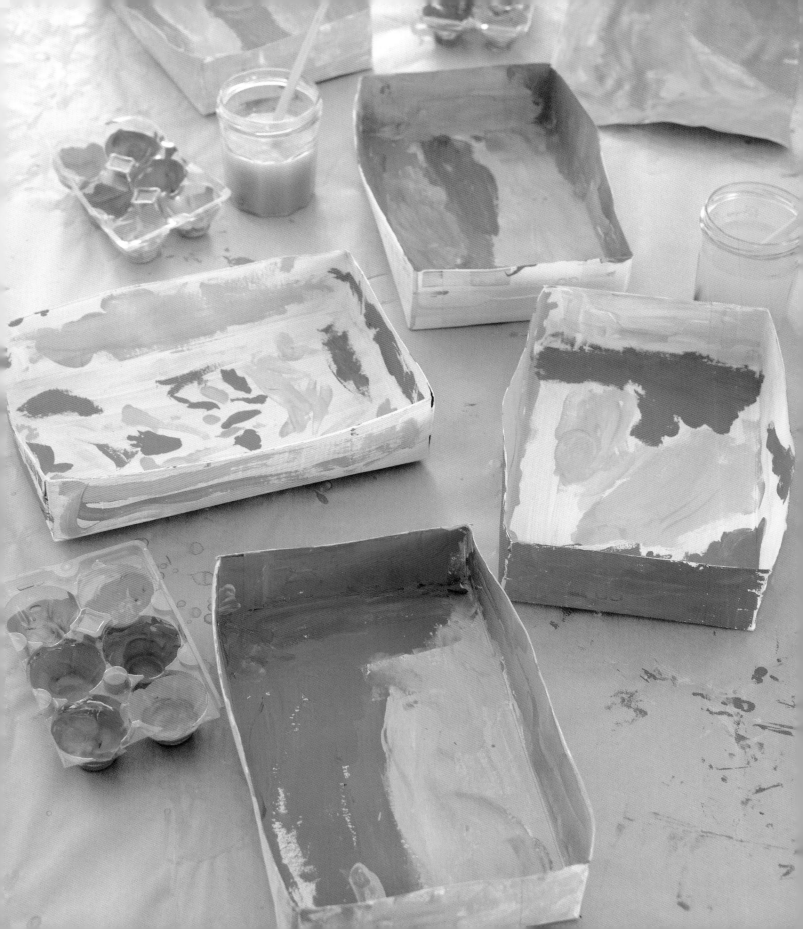

CEREAL BOX PAINTING

Cereal boxes are such a wonderful recycled material to have on hand. In this workshop, the children enjoy painting this boxy shape with colorful tempera paints.

GATHER YOUR MATERIALS

- Cereal box
- Scissors
- Masking tape
- White paint
- Brush
- Tempera paints
- Plastic egg carton or other containers
- Glass of water
- Damp sponge or paper towel

PREPARE YOUR SPACE

Prepare the cereal boxes the day before. I painted them white, but you don't have to do this. Cover your table with paper. Choose your paint colors, or let your child choose the colors and squeeze them into the egg carton. Set out a glass of water and something for wiping the brush in between colors, like a damp sponge.

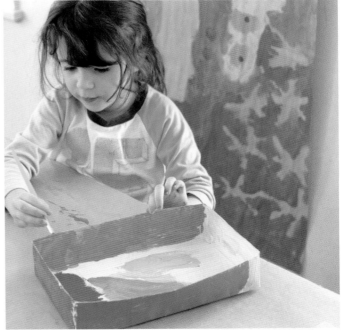

Painting a box with its many sides is more enticing than painting on just plain paper.

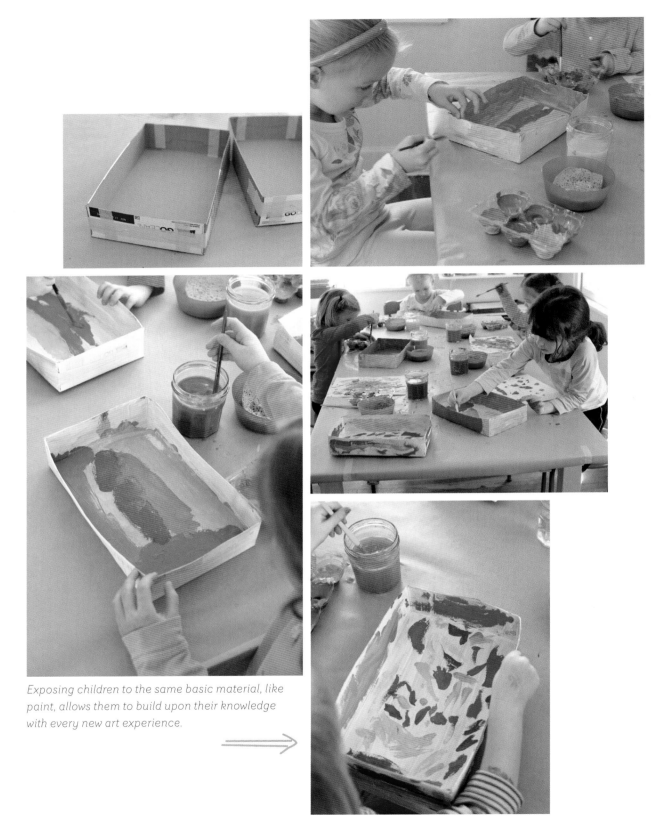

Exposing children to the same basic material, like paint, allows them to build upon their knowledge with every new art experience.

THE PROCESS

- To prepare the cereal boxes, just cut off one side. You will be left with a few loose pieces, which you can tape back together with masking tape. I then added a light coat of white tempera paint.
- The children painted their boxes in their own style, letting their brush move up and down the sides.
- If you want to hang them on the wall, just tape a piece of string to the back with masking tape.

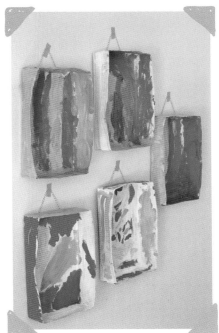

OBSERVATIONS

Painting a three-dimensional object, like a box, is a fun way for children to continue to explore the paint medium. We use tempera paints quite often in class. I like to expose the children to the same basic materials repeatedly so that working with them becomes second nature and they can start to express themselves in a more sophisticated way. Whether painting on a box, learning to make their paint more translucent with water, or mixing their own colors, the material becomes something with endless possibilities. The children then continue to build upon their knowledge with every new art experience.

VARIATIONS FOR NEXT TIME

- The finished pieces can be hung on the wall with a piece of twine or ribbon, or they can be used as a tray to store special things in the child's room.
- Gather collage materials, such as torn paper, old art, and fabric scraps, and glue them onto the box.
- Go on a nature walk with your children and collect leaves, twigs, pinecones, and whatever else you might find, and then use these materials to create a nature collage, or perhaps even a nature scene for older children.
- Let your children collect "small things" from around the house, like little toys, buttons, beads, or anything from the junk drawer, and glue them onto the box. Your child could paint the box first, then glue on the found objects to create a mixed-media, three-dimensional collage.
- Create an "All about Me" collage or diorama, using photos, words, and other collected materials.

Overheard:
"I painted all the sides. I'm even painting the bottom!"
—Chandler, age 4

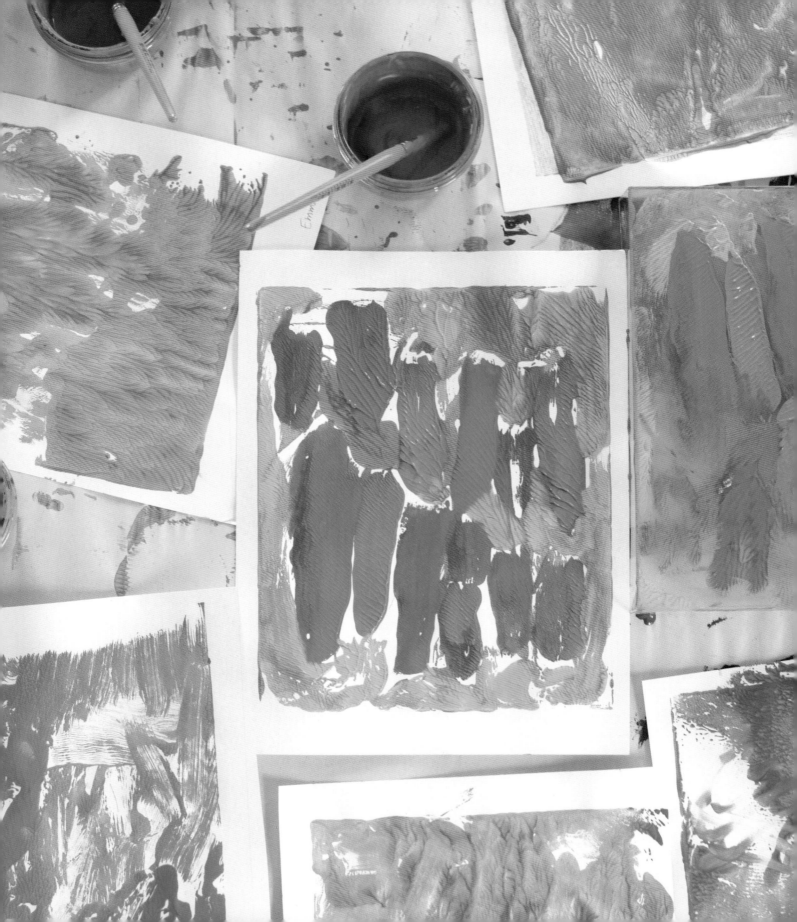

PLEXIGLAS MONOPRINTS

With a little paint and some inexpensive box frames, the children create one-of-a-kind prints.

GATHER YOUR MATERIALS

- Plexiglas frame
- Paper (sulphite or construction)
- Tempera paints
- Jars or cups to hold paint
- Brushes
- Roller (optional)
- Water and paper towels

PREPARE YOUR SPACE

Cover your table with newspaper. Printmaking can get a bit messy. Be sure to find a spot on the floor or a counter to lay out the prints to dry. Make sure your paper size is a little bit bigger than your frame so that it hangs over the edge. You can wash your frame with water and dry with a cloth or paper towels in between prints.

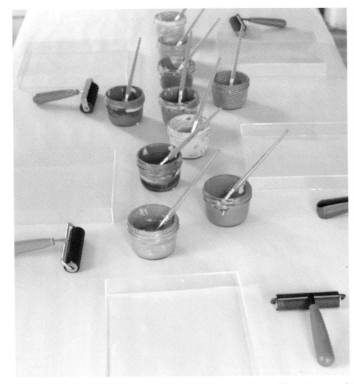 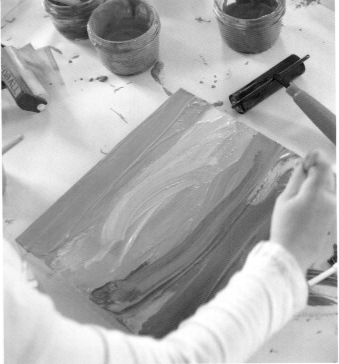

The children start by painting an image onto their Plexiglas, and then they transfer it to paper.

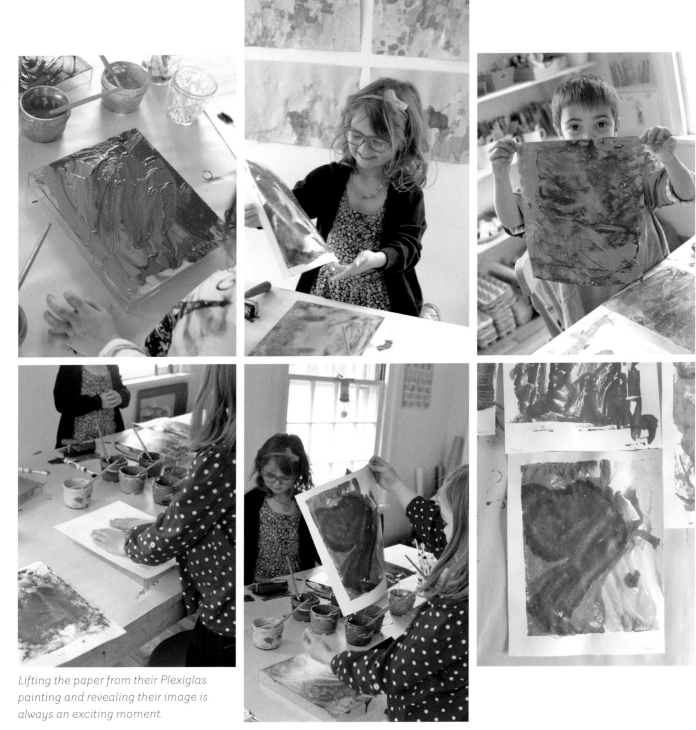

Lifting the paper from their Plexiglas painting and revealing their image is always an exciting moment.

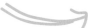

THE PROCESS

- The children begin by painting on their Plexiglas.
- Once they covered their whole surface, they gently laid down a piece of paper on top of the wet paint. I did show the children how to hold the paper on the sides and slowly lower it over their frame, trying to center it just so. Some children didn't care if their paper was centered, so I let them do what they wanted. Other children wanted a nice border, so they worked hard to place the paper carefully or asked for help.
- Once the paper was on top of the Plexiglas, the children used the rollers to make sure the paint transferred evenly. Or they used their hands.
- Lastly, they lifted up their print carefully to reveal their image (an exciting moment!).
- We cleaned the Plexiglas with water and dried them with a cloth or paper towel before painting again.

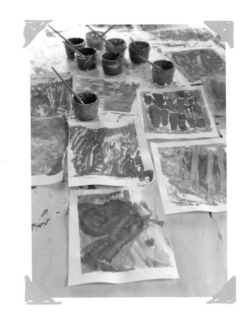

OBSERVATIONS

Printmaking workshops are my favorite. They are full of energy and movement. There is an immediate cause and effect during the art making, especially because these are monoprints, which means that there is only one print made from each image. Then they wipe it down and start over. As I watched the children work, I noticed how much they talked and communicated with each other. When one child was successful with his technique, he shared it with the group. And if something didn't work, the others were quick to suggest ways to fix the situation. They were thinking out loud, sharing ideas, and problem solving together. It was a beautiful thing to watch.

> Overheard:
> "I'm rolling my paper and making all the colors mix."
> —Sam, age 5

VARIATIONS FOR NEXT TIME

- Try using black paper and white paint, or white paper and black paint.
- Provide drawing tools, such as cotton swabs, for the children to use on their Plexiglas surface after they paint. Or have them first use a roller to apply their paint evenly, then use the writing tool.
- Print on newspaper, phonebook pages, or old book pages. The background lettering adds an interesting design element.

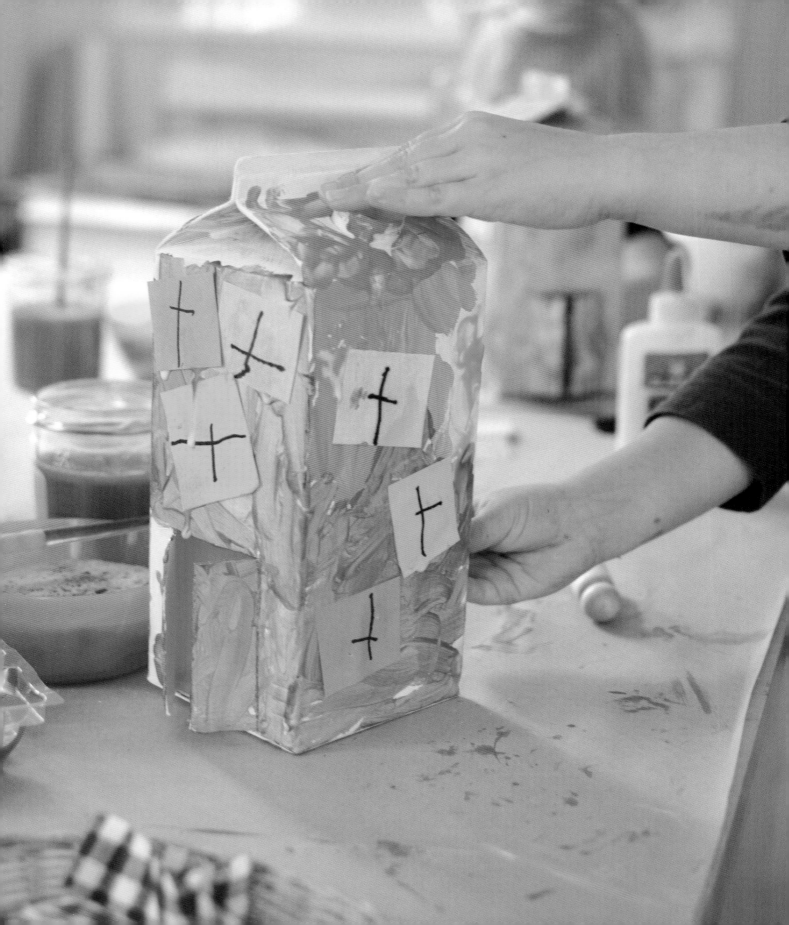

Chapter 4

WORKSHOPS // Art with a Purpose

"I invent nothing, I rediscover."

—AUGUSTE RODIN

I am a big believer in making do with what you have. More often than not, my workshops take form when I just spend time looking around the house and seeing what I have on hand. The more children use recycled and repurposed materials to support their emerging ideas, the more they begin to see that their immediate surroundings provide endless possibilities for creativity. In this chapter, the workshops are more purposeful. The children learn new skills to add to their creative language, and everyday objects transform into mobiles, masks, and toys for imaginary play.

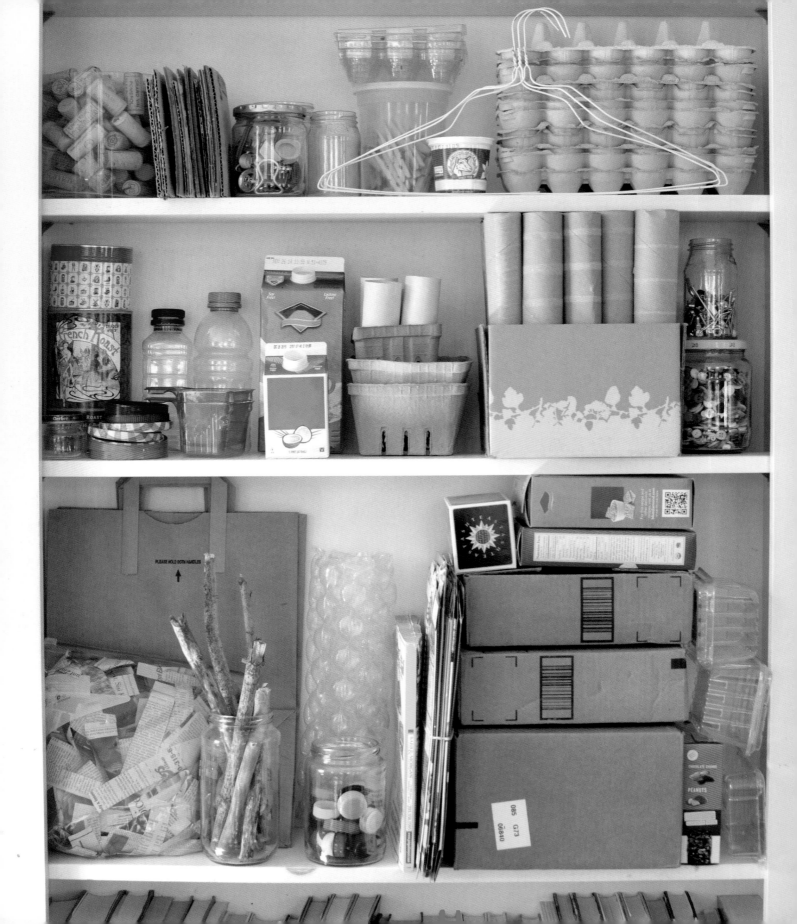

→ GATHERING MATERIALS

Recyclables

We dip into our bins of recycled materials each day in art class. You will see many of these materials in the pages of this book. I am proud to teach my students and my own children to recycle and reuse household materials. As an art teacher, I see possibilities where another might see *junk*. There is nothing more gratifying for children than having an idea in their mind, and then finding the materials for their idea right there in the recycling bin. Our motto in art class is "make with what you have."

TOP SHELF

Corks
Cardboard pieces from big boxes
Glass jars—baby food to pasta sauce
Plastic soup containers
Yogurt containers
Plastic egg cartons
Cardboard egg cartons
Wire hangers

MIDDLE SHELF

Coffee cans
Tin canisters or cans
Lids from jars
Plastic bottles
Laundry scoopers
Milk cartons
Creamer cartons
Strawberry containers
Toilet paper rolls
Paper towel rolls
Nuts, bolts, washers
Buttons

BOTTOM SHELF

Paper bags
Newspaper
Sticks
Bubble wrap
Bottle tops
Phone book
Cereal boxes
Cracker, snack, and tea boxes
Shipping boxes, small to large
Plastic berry containers

MORE IDEAS

Fabric scraps
Ribbon from packages
Old puzzle pieces
Mismatched socks
Old music CDs
Plastic milk jugs
Used wrapping paper
Old magazines, catalogs, and comic books
Wood scraps from carpentry
Pizza boxes
Blueprints
Maps
Tiles

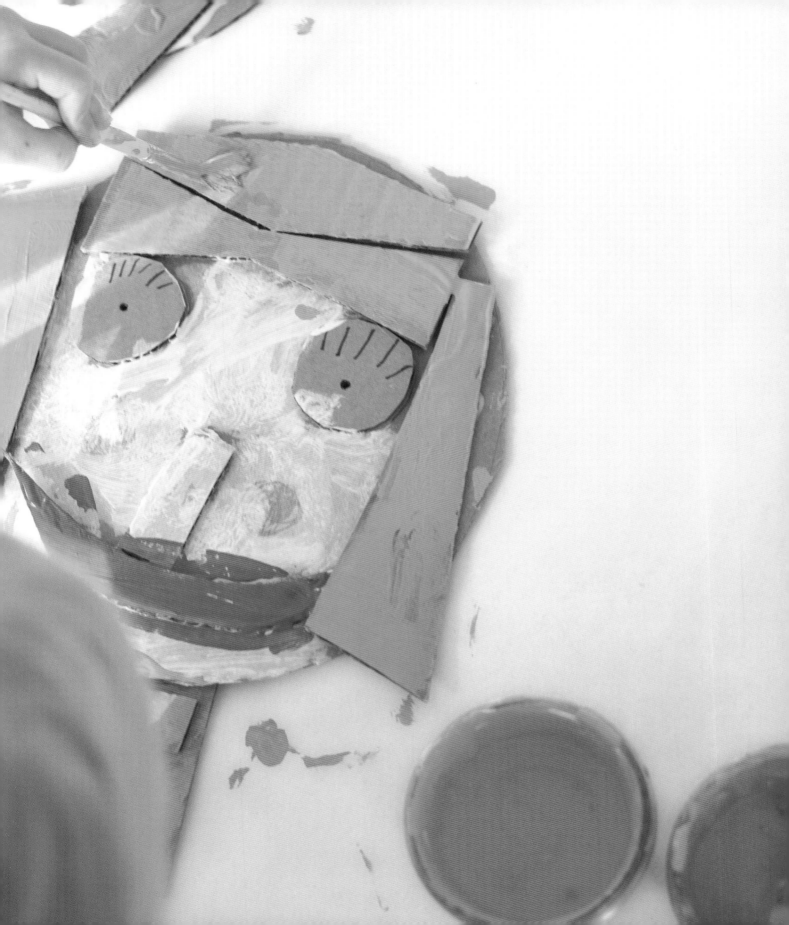

CARDBOARD COLLAGE FACES

We come back to the face time and time again. It is such a rich subject matter with so many opportunities to learn and discover and endless room for expression and interpretation.

GATHER YOUR MATERIALS

- Cardboard shapes
- Scissors
- White glue
- Black Permanent Marker
- Tempera paint
- Jars or containers to hold paint
- Brushes

PREPARE YOUR SPACE

Gather some containers or trays and sort the cardboard shapes into small, medium, and large shapes. Cover the table with newspaper. Check that the glue is filled and works properly. Prepare the paint jars but keep them aside until the children have finished gluing.

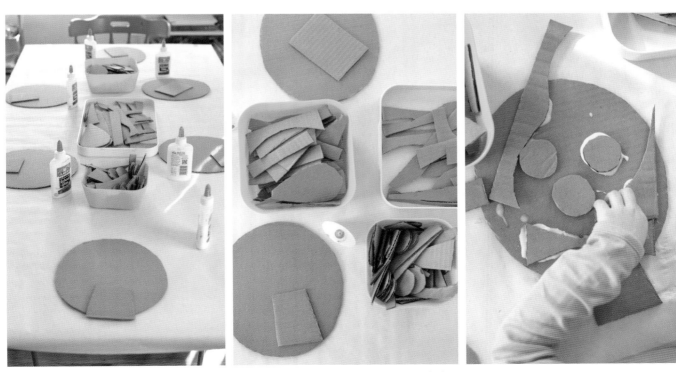

The children use cardboard pieces to create a face that reflects their own personal ideas.

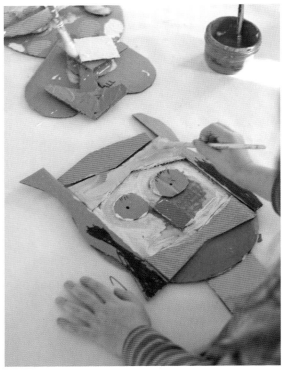

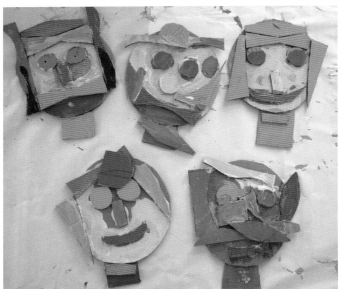

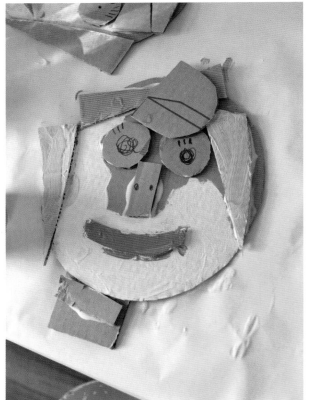

The children squeeze, layer, draw, and paint to design their faces. They use critical thinking skills to make their own choices about shapes, placement, and color. Each face is unique.

THE PROCESS

- Cut some shapes from cardboard: one for the face, one for the neck, and then various other small shapes for facial details. If you have a scrap bin of shapes, this is a perfect place to pull from. Although it takes some hand strength to cut through cardboard, older kids love to cut their own shapes.

- The children glue their neck shape onto their head shape, then pick and choose their own smaller shapes to create their face.

- When they are done gluing, bring out some permanent markers, such as Sharpies, for them to use to create more facial details. They are a better supply to use with paint, as they will not bleed when painted over. The children are more careful when using "grown-up" supplies.

- Lastly, bring out the paint. In a multistep workshop like this one, I like to stagger the presentation of new materials. It keeps the children focused on one element at a time.

OBSERVATIONS

We began by looking at ourselves in the mirror and touching all of the different parts of our face and neck. From there, the children were free to explore the shapes and create their own original faces. Children see themselves differently, and it's always so interesting to watch their work evolve. They squeezed glue, remembering our song of "a little dot will do it," and sorted through cardboard shapes to find just what they were looking for.

> **Overheard:**
> "My face is a boy with a hat and a tie. My boy likes pink and purple."
> —Olivia, age 4

VARIATIONS FOR NEXT TIME

- Use more than just cardboard for the facial features—put together a tinker tray of materials such as bottle tops, wine corks, buttons, and straws.

- Make alien heads or robot heads.

- Use colored paper scraps to collage the face instead of painting. Kids can cut their own shapes.

- Bring out pipe cleaners and beads at the end so the children can make necklaces, crowns, or other adornments for their faces.

- Glue the face onto a paint stick (one that you get to stir paint with from the paint store, which is free!) so they can be used as masks.

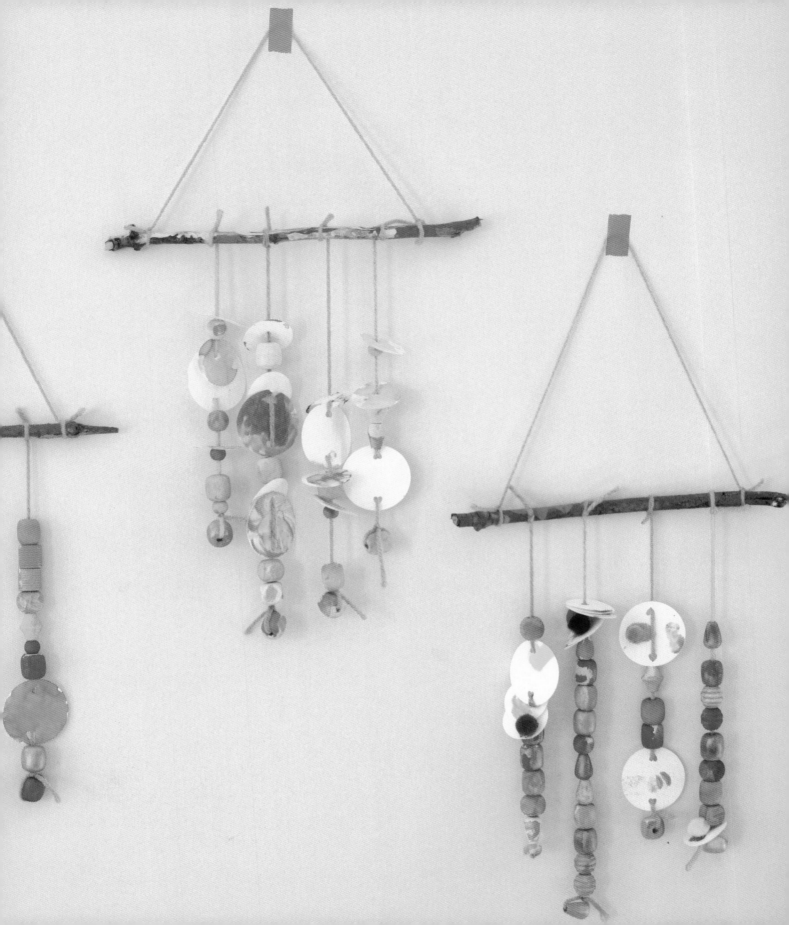

⟹ Workshop 18

WOODEN BEAD MOBILE

There are endless possibilities for making art when you combine such versatile materials as wooden beads and twigs. This workshop explores one way of making a mobile.

GATHER YOUR MATERIALS

- Wooden beads
- Paper towel
- Paper (a little heavier, like watercolor)
- Hole punch
- Liquid watercolors
- Egg container or small jars to hold paint
- Brush
- Glass of water
- Twigs
- Tempera paints (for the twig)
- Yarn

PREPARE YOUR SPACE

Cover your table with newspaper. Lay some paper towels on a plate as a place for the beads to dry. I used a paper punch to cut the small circles, but you or your child can just cut up bits of paper into any shape. Punch holes in the paper bits so that they can be beaded onto the string, or let your child punch the holes. As an option, gather some other supplies to embellish the paper, like pompoms, glitter glue, and oil pastels. Prepare the tempera paints and set aside with the twigs. Cut the yarn into long pieces. They can be trimmed later.

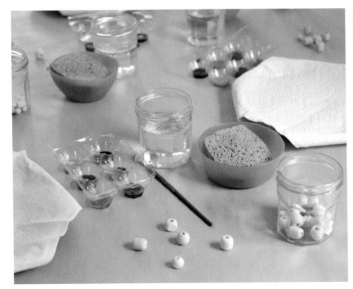
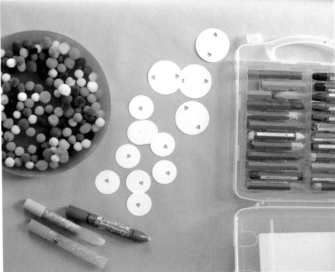

Painted wooden beads and paper bits combine to make a whimsical and colorful mobile.

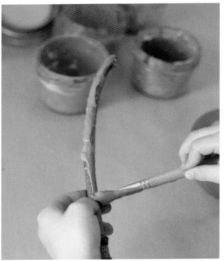

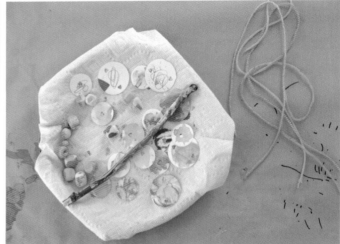

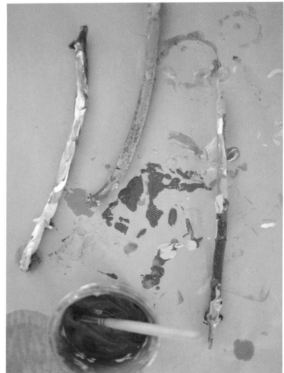

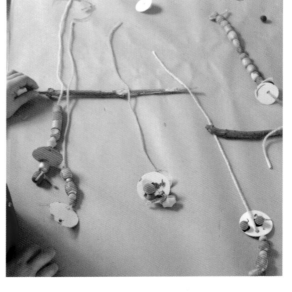

After the wooden beads and sticks have been painted and are dry, the children use yarn to string up their pieces, then a grown-up ties them to the stick at varying heights.

THE PROCESS

- This was a two-day process for the children. On the first day, they painted their beads, paper bits, and twigs. We let these dry overnight, and then the next day they assembled everything.

- When painting the beads with the liquid watercolors, hands will inevitably get some paint on them. Have some paper towels or a cloth nearby their workspace so they can wipe their hands.

- When it's time to string their beads, it's helpful to wrap a little bit of tape at one end of the yarn, like a shoelace.

- Let the children bead all four strands of yarn. For younger children, it's helpful to lay out all the beads and paper bits next to their yarn first. This way they are more likely to spread them out evenly, rather than bead them all on one strand.

- When the beading is complete, an adult can tie the yarn strands onto the twig at varying lengths. Then add a yarn hanger.

Overheard:

"This paint is like soup!"

—Mason, age 4

OBSERVATIONS

We use twigs often in our workshops. Traveling out and about in the yard and in the woods brings children closer to nature and allows them to view everything they see as a possible art material. On this day we used twigs we had collected the week before on a nature walk. They were so happy to see them back out on the art table. Children feel such great energy when they are using materials that they have collected or picked out themselves. It provides meaning and opens the door to bring even more of themselves into their work.

VARIATIONS FOR NEXT TIME

- Use plastic beads and found buttons along with the wooden beads. Silver bells would be fun, too.

- Use a larger stick and create more and longer strands. Older children might want to hang it from their doorway like a bead curtain.

- Wrap the stick with yarn instead of using paint.

- Use wire instead of yarn. Wire can be bent easily into different shapes, or wrapped around the stick.

- Make some paper feathers or leaves as shapes to hang on the ends of each strand. Or use real feathers and real leaves.

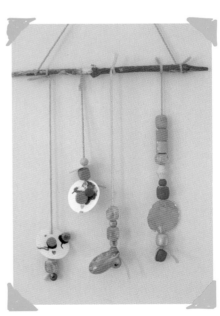

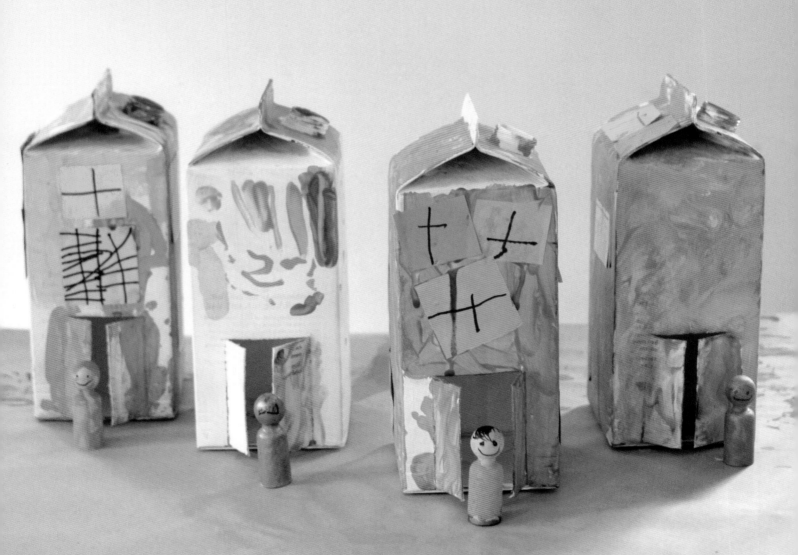

MILK CARTON HOUSES

Milk cartons are the ultimate recycled material because they are house shaped and have a little chimney!

GATHER YOUR MATERIALS

- Empty milk carton
- White paint (optional)
- Craft knife for cutting the door
- Tempera paints
- Plastic egg cartons or small jars to hold paint
- Paintbrush
- Glass of water
- Damp sponge for cleaning brush
- Little sticky notes
- Black marker or Sharpie
- White glue or glue stick
- Wooden peg doll (optional)

PREPARE YOUR SPACE

Cover your table with newspaper, or have your children work on a tray. Prepare the milk cartons the day before. Paint them white, then cut a door when dry. Gather some sticky notes and black markers and set aside.

Children paint their houses with colorful, fluorescent tempera paints before adding windows with sticky notes and a marker.

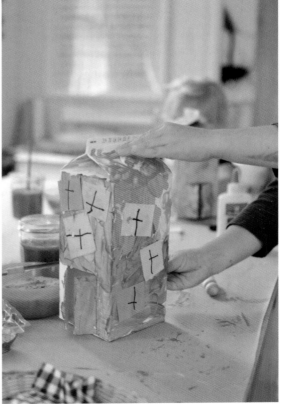

Each child paints her house in her own way and expresses a different point of view.

THE PROCESS

- Prepare the milk carton by painting it white, then cutting a door approximately 3 inches tall by 2½ inches wide (7.5 x 6.5 cm).

- Children paint their house any way they please. Remind them that there are four sides and a roof.

- Have sticky notes and a black marker set aside for when the children have finished painting. When they are ready, show them how to make a cross, which is the symbol for a window. Let them explore their window making.

- Provide some glue to stick the windows to their house.

- If you have peg dolls available, let them use their paint and Sharpie to create a little person.

OBSERVATIONS

There was a little more purpose in this workshop. It was still open-ended in that the kids were free to paint their houses in their own way, but there was an end-use and there was a skill to be learned: making windows! When learning and exploring how to make a cross, some children made one cross for each window, while others made multiple crosses on each square sticky note, practicing their mark-making over and over again. Some made no windows at all. Every child had a different point of view to express.

VARIATIONS FOR NEXT TIME

- Other things to make with a milk carton:

 Birdhouse: Your child can find a branch outside and glue it into the spout, glue twigs or Popsicle (craft) sticks to the roof, and cut a round hole instead of a door.

 Gingerbread house: You or your child can first paint the carton brown, then add white paint for the door and windows, and glue candy onto the roof.

 Boat: Turn your carton on its side and cut off one side, then use a stick and some fabric to make a sail.

- Collage your house instead of using paint; this way, you won't need to paint the carton white first.

Overheard:
"I put a window on the roof so that you can see the sky."
—Martina, age 4

RAISING CREATIVE THINKERS

"Children are not things to be molded, but are people to be unfolded."

—JESS LAIR

I was born in Holland. My memories of early childhood are rooted in the few photographs that exist of that time. Carrying a bucket on the beach, pushing a baby pram in the garden, scootering on the street with my brother and sister. We spent our time outside, playing with each other and with our neighbors. The mothers would be nearby, but doing their own thing. For my mom, her "own thing" was needlepoint and sewing. It's one of the most remarkable details about these old photos—almost everything we were wearing was handmade. She knit our sweaters, or her sisters did, she smocked our dresses, she even embroidered ladybugs on my beloved painting smock. Playing outside and watching my mom make stuff was an inherent part of my earliest memories.

We moved to the United States and I began kindergarten. It was a half-day program and I went in the afternoons. My mornings were spent at home, playing. My mom was good about giving me boundaries while also letting me freely explore my surroundings and the materials at hand. Some days I would play outside in the stream, getting my shoes wet and watching the daddy longlegs crawling across the leaves. I would come inside when I heard her ring the big bell, but until then there were no rules. Other days I would play with my dolls, preparing elaborate tea parties and cutting their hair. I spent hours decorating and organizing my room. I remember the apple green rug and the way I piled things around my bed in neat little stacks, my collection of gnomes always sitting at the top.

I'm pretty sure my mom never played with me. It wasn't like that. I was on my own, but happy. Making up semi-dangerous games with my brother, pretending to be Little Orphan Annie by rubbing dirt in my clothes, or exploring the woods with complete freedom. I used whatever was available to me, whether a stick or some fabric scraps, and created my imaginary world.

We were a quirky family, with simple Dutch values like honesty, hard work, and do-it-yourselfness. My parents were unconventional, but it was these differences that drew the artsy people into our lives. Over time, my mom's friends were all connected to creative endeavors in some way. One of them was a writer, another a painter, and another an art

teacher. They adored my European family, especially my mother with her accent and her funny yet practical ways. My life was filled with makers and creative thinkers. I didn't realize it at the time, but their influence on me would be profound. Without aunts, uncles, or cousins around, these family friends shaped my frame of mind.

Now that I am a parent, it is only natural for me to view my children through the lens of my own childhood. I've strived to give them the same creative freedoms that I had and to bring them up with a sense that they are capable of solving their own problems. But it is a different era that we live in now, and the pendulum has swung the other way, as it so often does from one generation to the next. We are sometimes described in the media as "helicopter parents," which is often true. We hover over our children, worrying about every stumble or loss of self-esteem. We are too quick to jump in and offer help. It is agony for us to just do nothing and watch our child fail. This label comes from a direct adjustment on our part to overcompensate for what our parents didn't give us. While freedom to experiment, explore, and problem solve in childhood is a great advantage on the one hand, on the other hand, there is a level of disconnectedness when your parents have no idea what you are doing or thinking.

There has to be a happy medium. I have been experimenting with this parenting thing for more than sixteen years, trying to find that just-right place between raising independent, creative thinkers and cultivating a deep connectedness. I haven't always done it right, but I have some insights and wisdom that I can share.

Bar at age three and a half in Holland, 1972, riding her scooter.

Bar at age three with her baby brother in Holland, 1972.

THE MOST IMPORTANT ELEMENT OF RAISING A CREATIVE THINKER IS . . .
Letting go.

If we want our children to be problem solvers and to think for themselves, then as parents we just need to get out of their way. We need to let go of not only our expectations of who they might become, but also of our fears of what might happen if we aren't there to show them the way. Just as my mother let me explore the woods behind our house on my own, so must we give our children the freedom to explore the world around them without our constant presence. This is the only way they will be able to trust their own instincts and discover how resourceful they really are.

THE FIRST KEY TO LETTING GO IS . . .
Trust.

If we can trust that our children will create their own path, then our children become worthy of that trust. Children are highly capable. They are inherently creative, optimistic, and resilient. If they are allowed to try and fail and try again—their own—then they will become like the early explorers of our nation, who kept forging ahead with grit and curiosity.

Let them follow their curiosities and indulge them their passions, all the while trusting that their actions and their choices are theirs to make. As parents, we are here simply to help them hash out ideas and provide a safety net. From this place of support and trust, our children will find creative solutions to their own problems and ideas. Trust is a gift that we can give to our children. It is not easy, but it is vital if we want them to be confident, thoughtful, and creative.

THE SECOND KEY TO LETTING GO IS . . .
Accept that things might get messy.

Letting go often looks messy, especially when it comes to creativity. If we, as parents and teachers, inhibit our children's exploration and always try to keep things neat, then we are missing out on the whole point of building a creative life. The point being that we are nurturing our children to be creative thinkers, to think outside of the box, and to come up with solutions to their problems. This can only happen when they are free to take risks and learn from their mistakes. And yes, this can often be messy.

Childhood is a wonderful time to explore these artistic boundaries because small children aren't yet worried about making mistakes. It's as we grow up that we become more reserved and less likely to test our creative impulses for fear of failure. How marvelous, then, to have been able to experience those early, artistic explorations as a child.

OTHER THINGS TO KEEP IN MIND WHEN RAISING A CREATIVE THINKER...

Let them play. When we value children's unstructured play and view it as one of the most important elements of childhood, we are supporting their lifelong love of learning. Whether they are learning practical life skills, social skills, small and large motor skills, or design skills, all play is learning. When we let our children play, we are also instilling in them a fun, playful, and creative attitude that will help them get along with others and problem solve throughout life.

Create a maker space. Encourage messing about. Carve out a place in your home, whether in their room, in the corner of the kitchen, in a garage, or in a closet, where they are free to create and explore on their own terms. Remember to let go of expectations and accept a little mess.

Indulge their curiosity. Whether they love cooking, dance, trucks, or singing, let's go out of our way to indulge their curiosities. This doesn't have to cost money, and we don't always need to sign up for a class. We just need to go to the library and get books, borrow an instrument, make a parking garage out of cardboard, or make a stage in the corner of the room. Whenever we help our child fulfill their passion, we are giving them the opportunity to self-motivate and master a skill, filling their well with knowledge and confidence.

Bar's two young daughters tinker about in the art room as her baby son explores movement in the jumpy seat nearby.

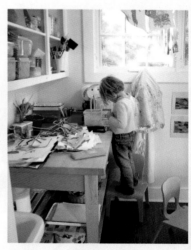

Bar's young daughter using the supplies at hand to create from her imagination.

Ask questions. When we ask open-ended questions, we are helping our child use language to elaborate on an idea, and we are showing interest in their play and work. Asking simple questions, such as "Tell me about your book" or "What else can you build?" begins a dialogue that helps us connect with our children and opens a window into their minds.

Model imperfection. We all make mistakes in front of our children. Whether we lose our temper and yell, drop the cereal on the floor by accident, or hammer a nail into the plaster wall and create a giant hole, mistakes are happening daily. If we apologize, clean up, laugh at our mishaps, and find creative solutions, we are modeling for our children how to fix and learn from mistakes. If our children can tolerate and move on from mistakes, they will take many more creative risks.

Visit museums. There are so many benefits to museum visits with children (and I have a great trick for making them fun). Museums are a shared experience between our child and us. We don't have to be an art expert; it's more about connecting with our child and talking about what we see. Museums are quiet, can be modern or different in architecture from what children normally see, span many cultures and therefore expose them to unknown worlds, can provoke their imagination, and are a place where art appreciation begins. My trick for a quick and exciting museum visit with children: Start at the gift shop. Let the children chose a handful of postcards that excite them. Read the backs together and talk about when the piece was made, the artist's style and color choice, and anything else that stands out. Then it's time to go on a search to find the real art that matches the postcard. Works like a charm!

Let them decorate their rooms. When we transition children to "big kid" beds, it's time to get their input. They can help choose the bed, pick out new sheets, select the color of their walls—and even help paint! (We can narrow down the choices for them first; that way, anything they choose is something we can live with.) As they grow, let them hang their own artwork, posters, magazine pictures, and photographs. I give my children some colored tape and let them arrange their walls however they want. All three of my children have days where they want a change, so they take everything down and move things around (even the furniture). When I walk back in, it's *all different*. The proud looks on their faces are worth the often-haphazard decor. When children are in charge of their own space it gives them a sense of autonomy, motivates them to keep things tidy, teaches them to respect other people's spaces, and helps them develop a sense of style.

Spend time with creative people. I think often of the crafty and creative adults that helped shape my life. My mother's friends were art teachers, artists, writers, and craftsmen. My dad was handy with tools and designed and built many things in our home. These were my creative influencers. Think about who might be your children's creative influencers and bring them into your family's life as much as you can. Talk about them with your children so they understand that creative careers are possible. If *you* are your child's creative influencer, then think about other families you might be able to influence. One day, maybe it's *you* who inspires a child to grow up and live a creative life.

With these elements in mind, we can begin to weave a bit of creativity into our lives. Every day won't be perfect, there is never perfect. Perfect is unattainable (remember, we are modeling imperfection). The point is to be conscious of letting go, ignoring the mess, asking the right questions, pointing out beauty, and noticing their choices.

On days where creativity is just not going to happen (there will be many of these days), then connecting with our children in a small way is good enough. We can share a funny photo or quote, read side by side, notice their stylish outfit, write a quick note for their lunchbox, hum their favorite songs and see if they can guess (or laugh at us), bring them a cup of tea, tuck them in tightly like a cocoon, kiss them one hundred times, hug them until they can't breathe. As long as we have connected once a day, we are doing a fine job.

Somehow, all of these little things together will add up to a beautiful effort that can really make a difference. Or at least I think it will. I'm still in my trial stage. Let's reconvene in another ten years and share notes.

During his "tools" stage, Bar's young son sets up his work station in the kitchen, making sure to tie all the supplies he might need to the top of his car with bungee cords.

Bar's two daughters connect with their father through puzzling.

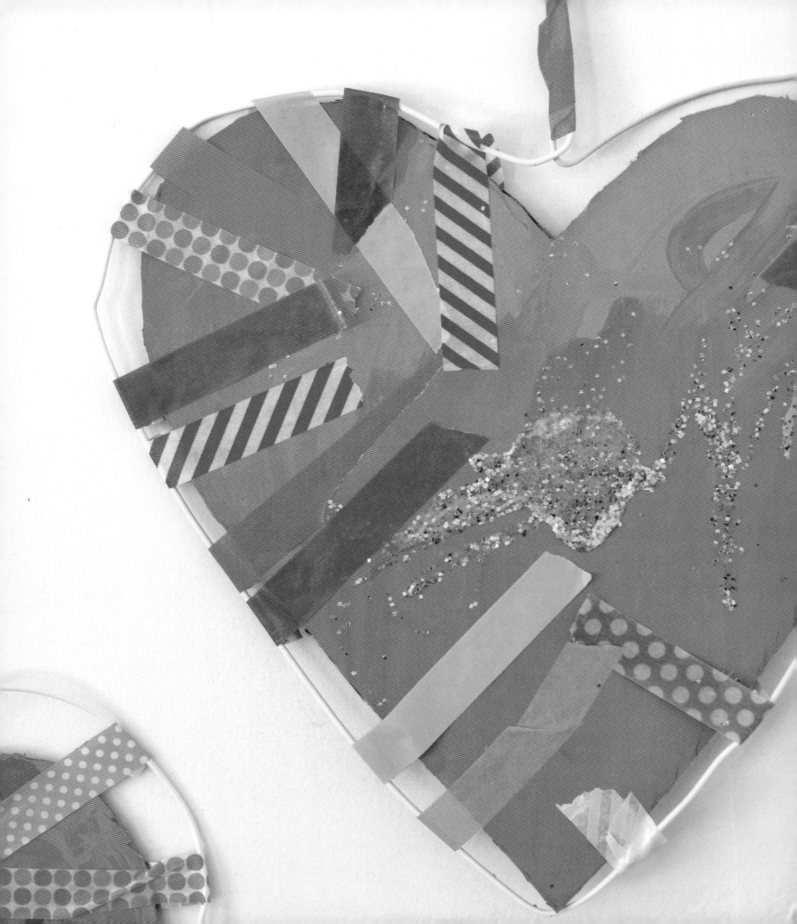

HEART HANGERS

*Cardboard hearts combine with washi tape and wire hangers
to make colorful art that you can hang anywhere.*

GATHER YOUR MATERIALS

- Cardboard
- Heart template
- Pencil
- Scissors or craft knife
- Tempera paints
- Jars or containers to hold paint
- Brushes
- White glue
- Glitter
- Wire hanger
- Washi tape
- Beads (optional)

PREPARE YOUR SPACE

Cover your table with newspaper for an easier cleanup. The paint is not that messy, but the glitter can be. Find some wire hangers and bend into shape. Trace the heart template onto cardboard and cut out the hearts so that they fit inside the hanger. Mix the paint colors. We used colors in the traditional red color family, but you can use any colors. Or let your child choose the colors. Gather the glitter and glue and put them aside on a tray. Gather some beads and tape and set aside for day two, after the hearts have dried.

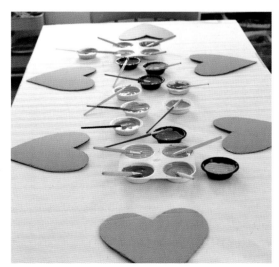

The first step in making these heart hangers is painting the cardboard hearts with tempera paint.

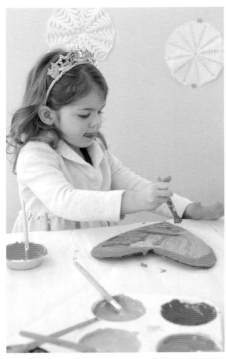

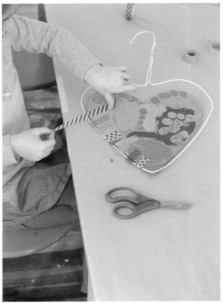

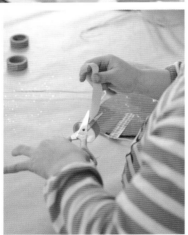

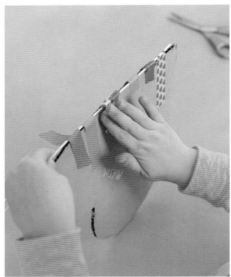

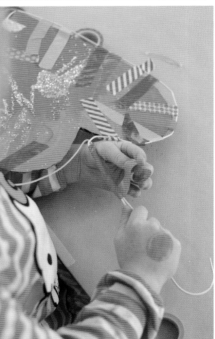

When the hearts are dry, the children use colored tape to attach them to the hanger.

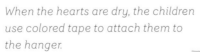

THE PROCESS

- The first step is to bend the wire hangers into a heart shape. This is not easy, but it's doable. Alternatively, if you don't have a wire hanger, you can use craft wire, which is much easier to bend.

- Once you have your wire frame, then you make a heart template out of paper that fits nicely inside the frame.

- Use the template to draw and cut out the cardboard hearts. If your children want to cut their own hearts, you can give them cereal boxes instead, which are much easier to cut.

- Let your children paint their hearts any way they please.

- Give them the glue and glitter when they are finished painting. The hearts must dry overnight before taping.

- When the hearts are dry, the children use colored tape to attach them to the hanger. We did talk for a minute about placing the tape half on the front of the heart, and then wrapping the other half around to the back.

- Lastly, the children put some beads on the top of the hanger and secured them with more tape.

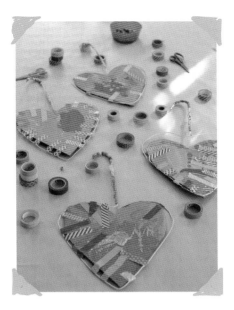

OBSERVATIONS

I believe that around age five, children are ready and capable of making "something." They have spent many years exploring the materials and learning skills, and at a certain point they are excited by a multi-step workshop. As with all of my workshops, a large part of the art making is open-ended. There are no limits on how they can paint their hearts, or what materials they can use to decorate their hearts. They also choose, cut, and wrap their own tape and choose their own beads. Each finished piece is unique, and the process is central to their creativity, but they have all had a common experience of using their hands to make a finished piece. They are learning the "behaviors of making" that will build their confidence and open up new possibilities.

Overheard:
"My paint is like icing.
I want to eat it."
—Abby, age 4

VARIATIONS FOR NEXT TIME

- Instead of thick cardboard, use thinner cereal boxes and punch holes around the perimeter so that the children can use yarn to attach their heart to the hanger.

- If you don't have any wire coat hangers, or if they're too hard to bend into shape, just punch one hole at the top of the heart and use yarn or craft wire as a hanger.

MINI CANVAS PAINTINGS

This workshop is a simple art invitation for the children to paint on canvas, an unexpected material that provides a new experience.

GATHER YOUR MATERIALS

- Cotton canvas
- Scissors
- Tempera paints
- Plastic egg carton or small containers to hold paint
- Brush
- Glass of water
- Damp sponge for cleaning brush

PREPARE YOUR SPACE

Cover your table with newspaper. Cut small pieces of canvas, making sure each child has several. Choose colors to fill the plastic egg carton, or let your children choose the colors. Place a damp sponge in a small bowl for cleaning off the brush in between colors.

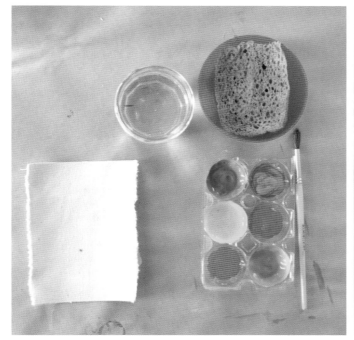
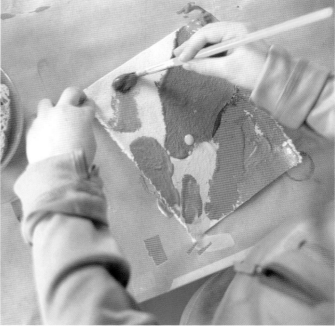

Small pieces of cotton canvas and bright tempera paints are an inviting setup for the children.

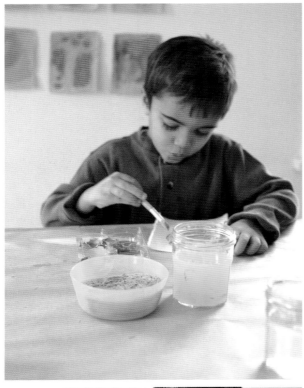

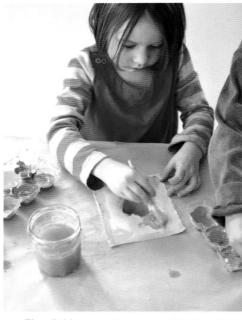

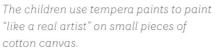
The children use tempera paints to paint "like a real artist" on small pieces of cotton canvas.

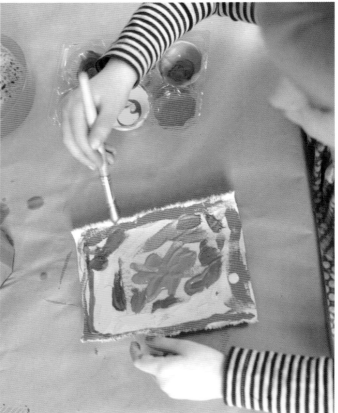

THE PROCESS

- To cut the small canvas pieces, I took a large piece of canvas and made a small cut every 4 inches (10 cm) down the side. I then used that small cut to begin tearing the canvas until I had several strips. Tearing canvas is easy and it's the best way to get a straight line. From there I just cut the strips every 6 inches (15 cm) so that I was left with 4 by 6-inch (10 by 15 cm) pieces. You could also make them 6 by 8 inches (15 by 20 cm) or any size. But it's best to keep it small, as this workshop is about exploring paint on canvas and the small size is good for beginners so they can experiment many times.

- Once the invitation has been set out on the table, the children are free to investigate on their own. Just let them paint!

OBSERVATIONS

Before the children sat down at the art table, I walked them around my house to show them some paintings that my dad painted (his name is Ruud Bergmans and he's a working artist in New York City). I let them run their hands across the surface of these large paintings and I pointed out that they were painted on a fabric called canvas. Their eyes got very wide because this was new and exciting information! We moved to the art table and they began to paint. They'd seen these paints so many times before, but they had never experimented with painting on canvas. I overheard a child saying, "I am painting like a real artist!" They spent 40 minutes painting and at the end of class they asked if they could do it again next time. A simple art invitation with one new material plus an opportunity to "paint like a real artist" turned into a two-day study. The children were absolutely captivated.

> **Overheard:**
> "It feels sticky under my brush. I just need more paint."
> —Clare, age 4

Tip: *When painting with temperas, there is a technique that I teach at home and in art class that I learned from my children's Montessori school. It goes like this: paint, water, sponge, repeat. Choose a color, paint with it, rinse your brush in water until it's clean, dry your brush on the sponge, then choose your next color, and so on. Using this system from an early age will train your child to keep the colors clean, which is important when sharing paint in a group. If your child is painting alone and likes mixing colors and doesn't care if everything turns brown, then let him explore and experiment to his heart's content!*

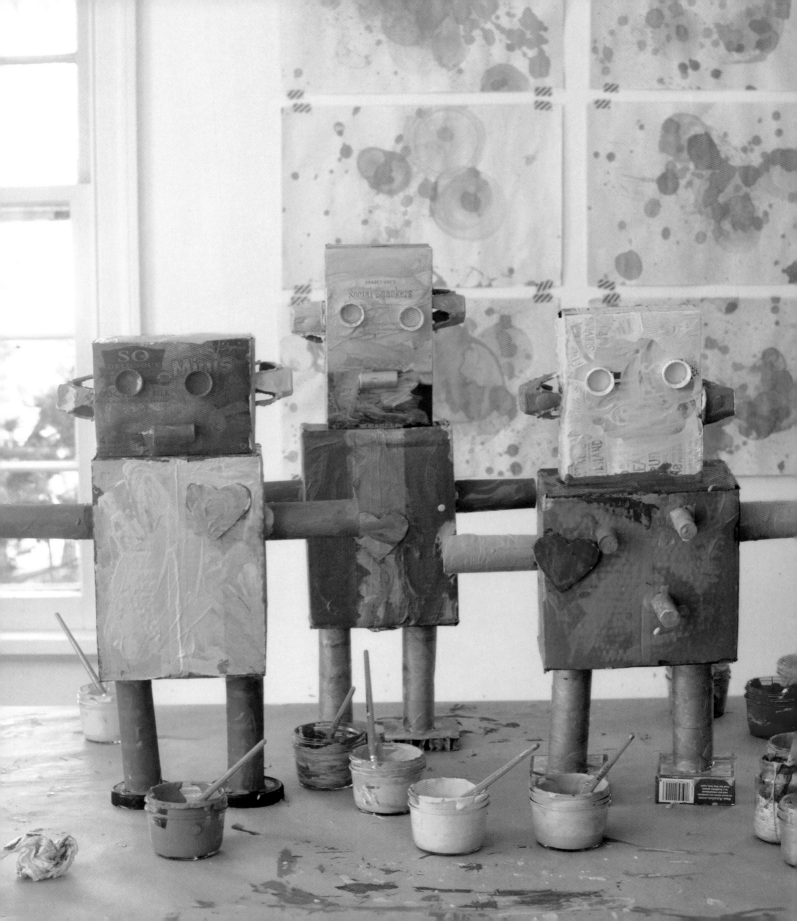

RECYCLED ROBOTS

Recycled materials come to life when the children put them together to make robots.

GATHER YOUR MATERIALS

- Small recycled boxes
- Other recycled materials, such as bottle tops and lids, corks, yogurt containers, egg cartons, and toilet paper and paper towel rolls
- White glue
- Hot glue gun (optional)
- Scissors
- Tempera paints
- Containers or jars to hold paint
- Brushes

PREPARE YOUR SPACE

Cover your table with newspaper. Gather boxes in several sizes, from small Jell-O boxes to medium cracker boxes to bigger shipping boxes. Gather other recyclables, or let your children make their own choices. Prepare the paints for day two, after the glue has dried. Or your children can choose their own paint colors.

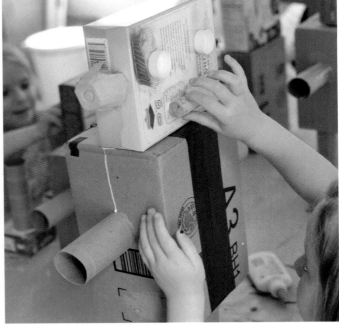

The children make choices about size and shape to assemble their robot body and face.

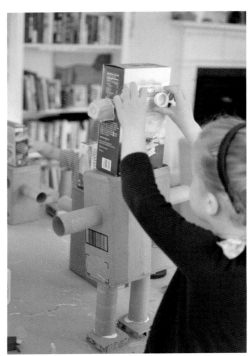
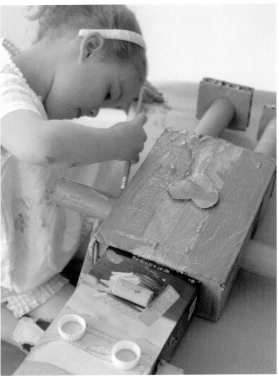
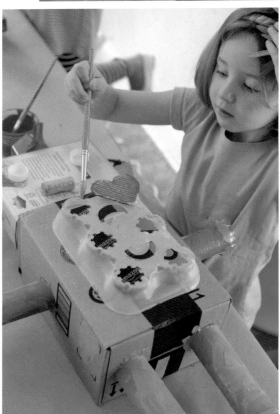
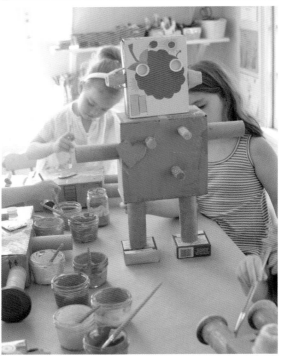

After assembling their recycled parts and waiting for the glue do dry, the children are ready to paint their robots.

THE PROCESS

- This workshop takes place over two days. On the first day, the children choose their recycled materials and assemble them into a robot.

- A word about glue: I initially put out white school glue but soon realized that I needed to bring out my glue gun, too. The white glue just wasn't strong enough against the force of gravity. If you don't have a glue gun, no problem. You can try wood glue which dries faster than white glue, or you can simply use masking tape to tape the parts together.

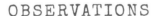

- After the robots are dry, the children can paint them! Since art class is only one hour, I usually mix the paints before the children arrive. However, children are very capable of choosing and mixing their own paints. Allowing them to explore and experiment with color will foster decision making and build their confidence.

- I cut out a cardboard heart for each child to place wherever he or she wanted.

OBSERVATIONS

During this workshop, there were so many wonderful opportunities for me to talk to the children about their art. Notice and comment on some details, like color or size or shape. I might say:

- "You added three corks to the front and fit the heart on the side."
- "I noticed how carefully you painted the many different sides."
- "The plastic bottle holder on the front is so interesting."

Acknowledging their effort in the creative process lets them know you are paying attention.

Overheard:
"I'm painting on plastic and it keeps disappearing!"
—Merritt, age 4

VARIATIONS FOR NEXT TIME

- Other great recycled materials include water bottles, milk jugs, creamer cartons, tin cans, disposable pie tins, laundry detergent scoopers, tissue boxes, and ice cream containers.

- Instead of painting, the children can use collage materials, such as colorful paper scraps and fabric scraps, to "dress" their robot.

- After the glue has dried, bring out some tinfoil and let the children wrap their robot's body and arms and legs. It might be best to cut the tinfoil into smaller pieces.

→ Chapter 5

WORKSHOPS // Collaboration

"It is through others that we develop into ourselves."

—LEV VYGOTSKY

Wonderful things can happen when children work together: greater energy, words of encouragement, consideration of equality, thinking out loud, taking leadership roles, listening to other opinions, generating new ideas. Even the most reserved child will find her voice when working together with her peers toward one common goal. When friends support your good idea, confidence grows. In these next five workshops, the children work as a team and discover that making art together is both exciting and natural.

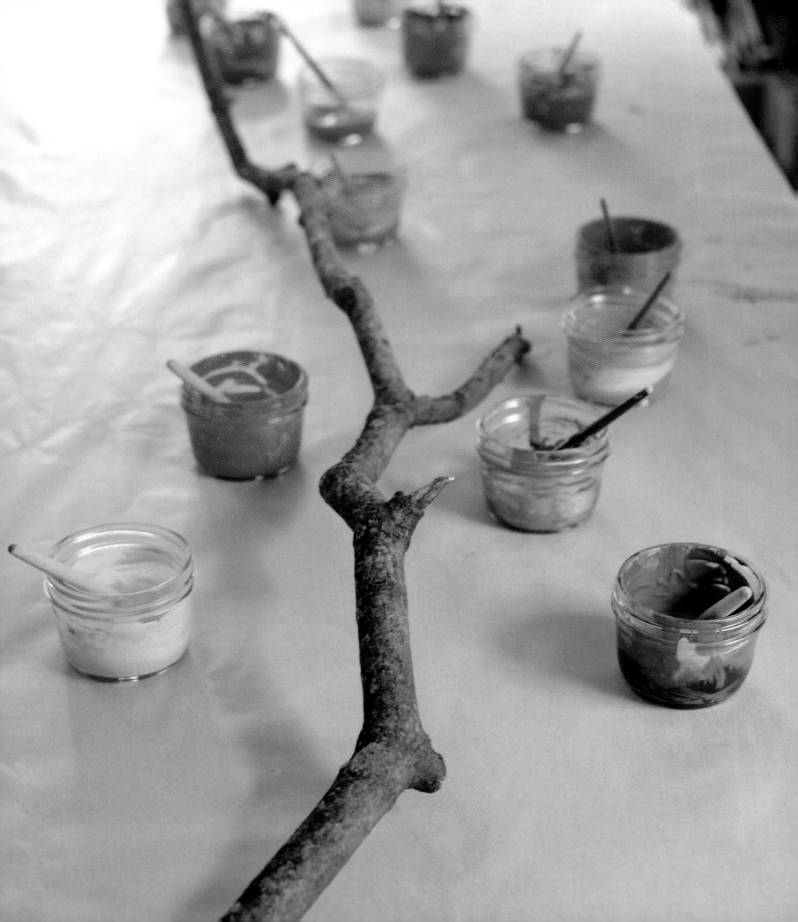

BRANCH PAINTING

Fallen branches are made to be gathered and painted!
This collaborative workshop will appeal to children of all ages.

GATHER YOUR MATERIALS

- Newspaper or brown craft paper
- A branch that has fallen to the ground
- Tempera paints
- Jars to hold paint
- Brushes
- Pompoms
- White glue

PREPARE YOUR SPACE

Cover the table with newspaper. Prepare the paints in jars with lids. If you're not going to make finding the branch part of the group activity, bring the branch inside a day ahead and let it dry out.

Tip: *When mixing your paint colors, add a splash of white. This will make the paint more opaque, which is important when painting on the brown branch.*

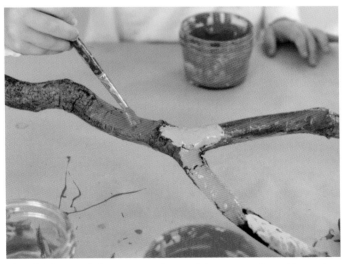

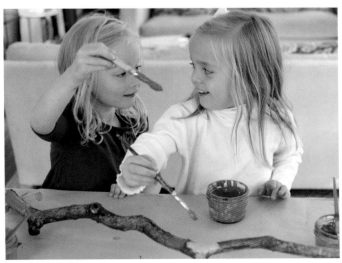

The children collaborate to paint and decorate a found branch.

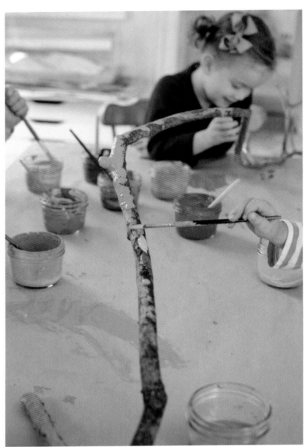

Children are such social beings that collaboration is a very natural way for them to make art.

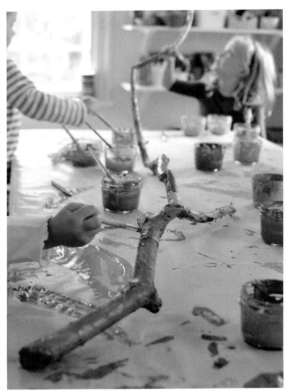

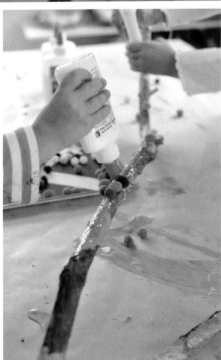

THE PROCESS

- Go outside with the children and find a big branch. Drag it inside.
- Now let the kids paint! There are no instructions, no rules (other than mind your neighbor when splatter painting). This workshop is about exploring a new material together as a group.
- Bring out the pompoms and glue after the kids have finished painting.

OBSERVATIONS

Collaboration is a natural way for children to make art because they are such social beings. They love to think out loud and share ideas as they explore the materials in their own way. When children work together toward one common goal, they feed off of each other and take more risks in their art making. This workshop would be great if you find yourself with a houseful of children, such as at a family gathering, a birthday party, or a play date. You will love overhearing their conversations and remarks—I know I did!

VARIATIONS FOR NEXT TIME

- Instead of paint, collage the branch with glue and small paper bits. For added sparkle, use glitter glue.
- Cut 12-inch (30 cm) yarn pieces to wrap around the branch.
- Glue flowers and leaves onto the branch after going on a nature hunt.
- Give each child a smaller branch of his or her own, or a stick to decorate in the same way, then put them all together in a vase or jar.
- Glue on some clothespins and hang the branch up on the ceiling with fishing wire, and use it as a way to display art.

Overheard:

"It's bumpy on my brush."
"Hey, we're both using pink!"
"Let's turn it over so we can paint the bottom."
"I need the yellow. Let's share yellow."
"My glue is dripping down on the paper."
"Look at me! I can paint the tippy top."

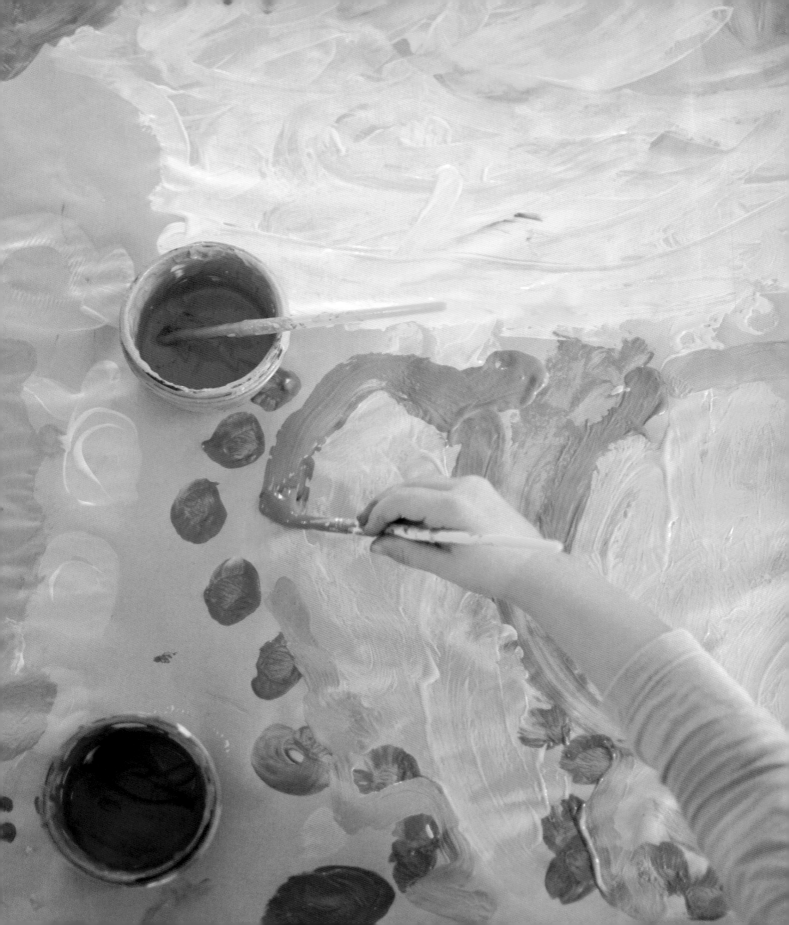

COLLABORATIVE TABLE PAINTING

Painting on the table is a thrill for the children. They stretch their arms to fill every spot with paint. This workshop is as much about teamwork as it is about design.

GATHER YOUR MATERIALS

- Brown or white craft paper roll
- Masking tape
- Tempera paint
- Jars for the paint
- Brushes

PREPARE YOUR SPACE

There is little prep for this workshop other than covering the table with paper and mixing the paints. The floor does not get messy, but the children's sleeves do. Although tempera paints are washable, it's best to dress for mess! They should wear clothes you don't care about, or wear a smock.

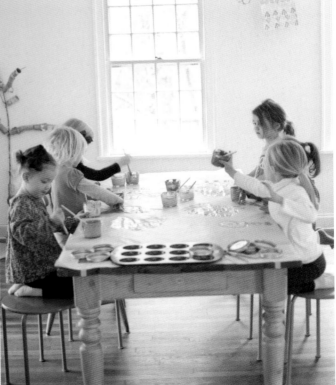

With this simple creative invitation, the children sit down together to make a big painting.

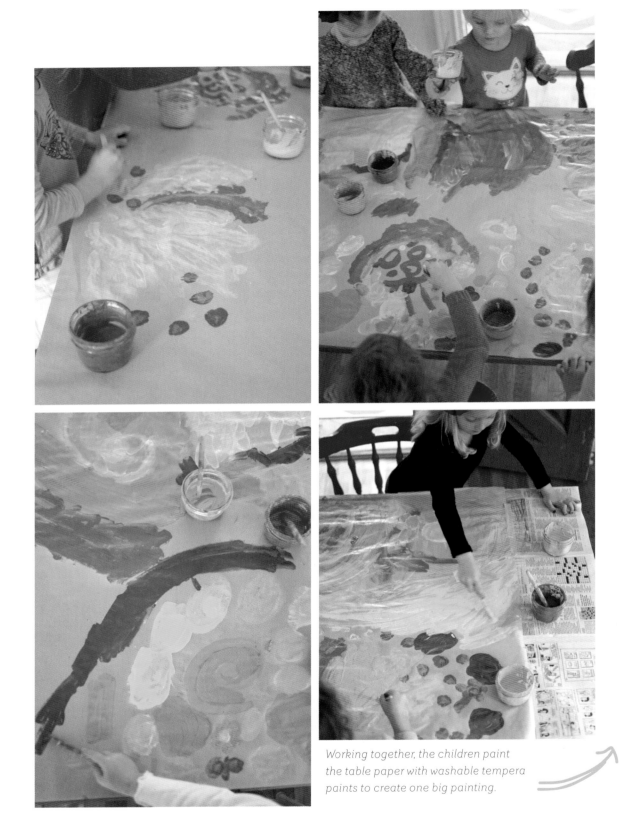

Working together, the children paint the table paper with washable tempera paints to create one big painting.

THE PROCESS

- We have made many, many table paintings in art class. It's such a easy setup with just paper and paint. The children do the rest.

- Sometimes I prompt them by telling them to start with circles. This gets their arms moving in a bigger motion. But soon the circles turn into other things, and by the end they are painting freely from the heart.

OBSERVATIONS

This simple process art experience is very fulfilling for the children for many reasons. First of all, they are allowed to paint directly on the table. This is quite exciting because their only boundaries are the edges of the table. Second, they are really stretching and using big arm movements, and sometimes their whole bodies, so there is great energy to their strokes. And last, there is a teamwork aspect to this workshop that fosters cooperation and a certain amount of cheerleading. The children pass the paints to each other, help move the paints out of the way, take inspiration from one another, and spontaneously compliment their friends. At first it is just about painting the one spot they are in, but as they realize that they are working together as one, they suggest colors for each other and hand them across the table. Such wonderful life skills are being learned by working in this shared space together.

Overheard:

"I'm stretching my arms too far. They are so tired."

—Charlotte, age 4

VARIATIONS FOR NEXT TIME

- Try drawing a large grid so that each child has his or her own large square. Then play "musical chairs" so that they each move over one spot, until all the children have painted in all the squares.

- As a "part two," bring out collage material and glitter glue.

- Give the children small paint rollers to use on the paper. Or cover the paint rollers with bubble wrap for a textured effect.

COLLABORATIVE ART:
SPARK AN IDEA . . . IGNITE THE MIND!

One idea creates a possibility . . . many ideas create a movement.

There is great power that comes from a single idea—a single mind seated at a single workspace. Yet, there is even more momentum when that single idea is surrounded by others in a group workspace. This shared space increases the possibility of a small seed growing into a bigger plant. As we know, no two minds think alike, and if that's the case, why not bring as many thinkers together to explore, discover, and create the potential of each other's ideas?

Collaborative art is a group experience that provides space and time for individual and collective thinking and exploration. As a young child in art class, I remember well the initial panic when receiving an open-ended task. Whether I lacked the confidence or just the time to explore the materials and develop my ideas, I began the process with a creative block. My default was to draw a three-circle clown with an ice cream cone cap with four puffballs down the front. That was it—that was my single creative expression! I had contributed, but I also knew that I was repeating the same idea and it lacked originality. How could I have unlocked my creative potential?

Given what I know now from my experience with children in the classroom, I am certain that my creative block would have been eased had I been seated around a table with others. I needed to see others explore. I needed to hear my friends talk out loud. I needed permission to color outside the lines. I needed encouragement to play with materials in my own way, with no right or wrong. Had I been seated around a shared space with these circumstances in place, I wonder what I might have done.

Children need freedom to think out loud and create together. They need to observe, chatter, mingle, experiment, hypothesize, and explore. This collaborative setting has the potential to foster and cultivate original thinking. One idea triggers another and from there, multiple ideas develop. Children benefit from being in a shared space hearing shared ideas. This kind of environment serves as a catalyst for encouraging original thinking. Confidence grows, risks are taken, the unexpected occurs, possibilities are revealed, and new ideas develop.

Collaboration + Art Workshop = Essential Life Skills

Whether around an art workshop table, a science lab table, a kitchen counter, a theater stage, an architectural plan, a conference table . . . these essential skills are necessary for creative productivity. Children are our future adults, and in this twenty-first century, they must be prepared to work, and think, in shared spaces. They must have the confidence to generate shared ideas that become a catalyst for new and original ways of thinking.

Confidence grows. Risks are taken. The unexpected occurs. Possibilities are revealed. New ideas develop.

Spark an idea . . . ignite the mind!

—*Betsy McKenna*

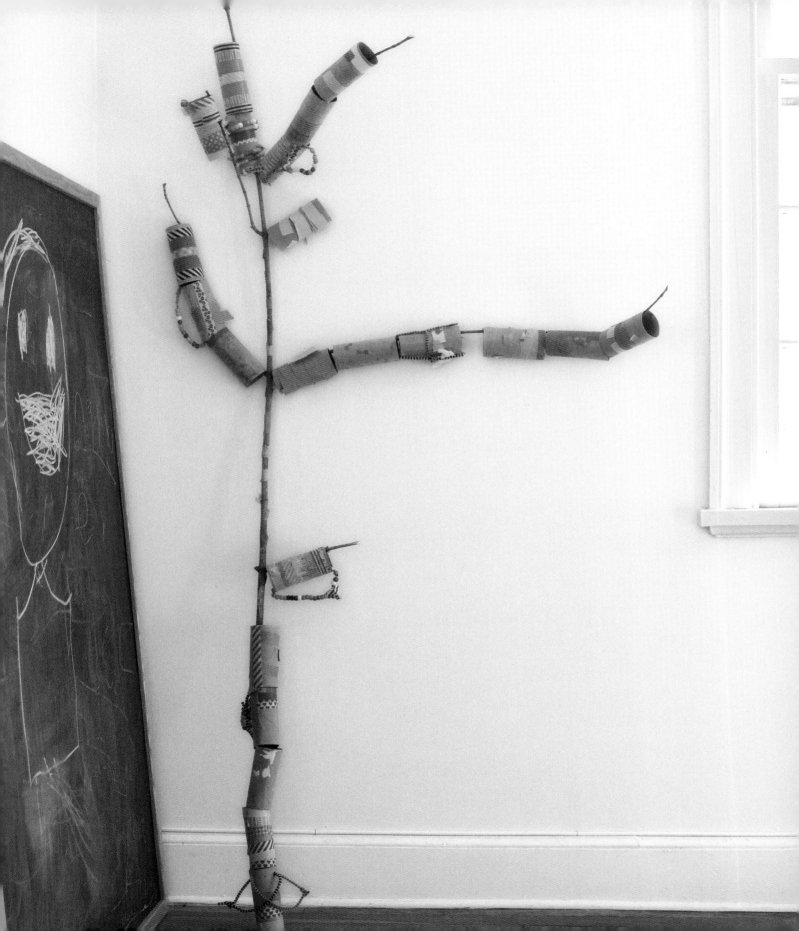

PAPER ROLL TREE

This workshop was a collaboration between several art classes. The children added to the branches each week until finally it became a fully bloomed tree.

GATHER YOUR MATERIALS

- Rolls (either toilet paper or paper towel)
- Washi tapes
- Scissors
- Pipe cleaners
- Beads
- Chalkboard markers
- A big branch

PREPARE YOUR SPACE

The materials in this workshop can be gathered with your child or children, or you can collect everything beforehand and place it all on a big tray or some baskets. There is no mess, no need to cover your table. Choose a table where supplies can be left out for a week. Go outside and pick a branch out together.

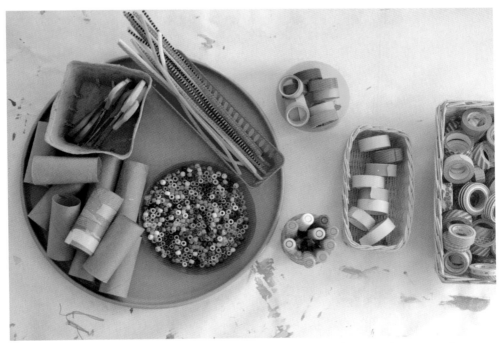

A colorful and inviting table of materials entices the children to decorate the paper tubes.

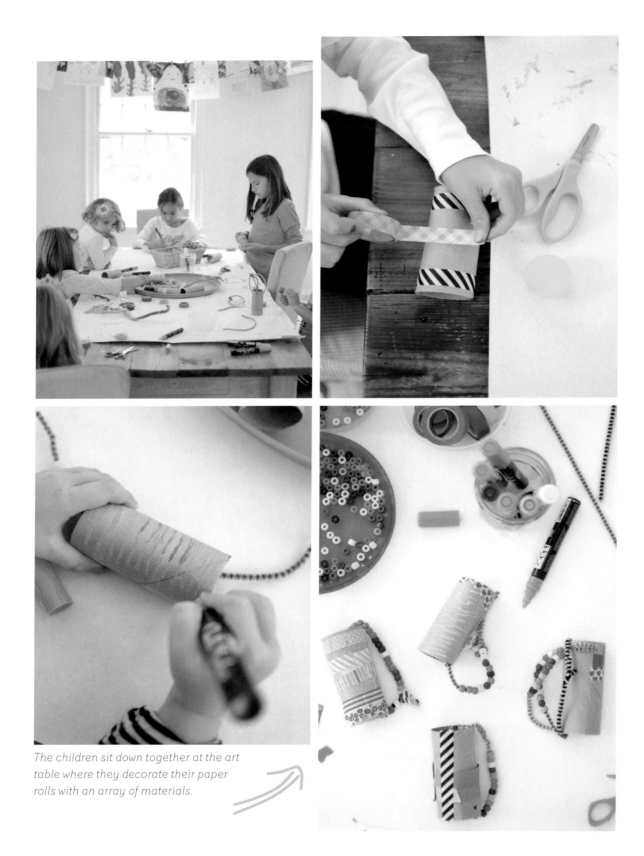

The children sit down together at the art table where they decorate their paper rolls with an array of materials.

THE PROCESS

- This workshop is a simple creative invitation. I just left a tray of materials and a few baskets of tape out on the table with a pile of paper rolls. The children spent part of each art class at this table and decorated their rolls however they pleased.

- At first I put a rake out in the corner and they stacked their rolls on the handle. Then one day, after a windy night, we went outside and found the perfect branch on the ground. The children broke off a few smaller branches from the bottom so they were able to fit all the tubes.

- One child decided to embellish the branch with some more colored tape.

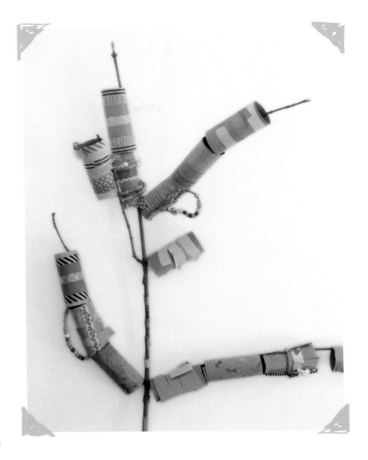

OBSERVATIONS

It was so enjoyable to watch this collaboration unfold. The children ranged in age from four to eight. The older ones were more imaginative with the pipe cleaners and beads because of their skill level, and the little ones were more likely to spend time choosing and working with the tape. They both inspired each other. By the third day, the older kids went back to their earlier paper tubes and added tape, while the little ones made holes with their scissors and figured out how to snake the pipe cleaners through. The wonderful thing about this multi-age, collaborative setting is that the children hear ideas floating around from others and it sparks a new idea for them. When children—or even adults, for that matter—share a communal creative space, it has the potential to stimulate exciting and original ideas.

VARIATIONS FOR NEXT TIME

- Other materials that can be used to embellish the rolls include watercolors, tempera paint, collage bits with glue, glitter, oil pastels, chalk, elastic bands, wire, and pompoms.

Overheard:

"I made a handle!"
—Maya, age 4

"I'm making a pattern."
—Charlotte, age 4

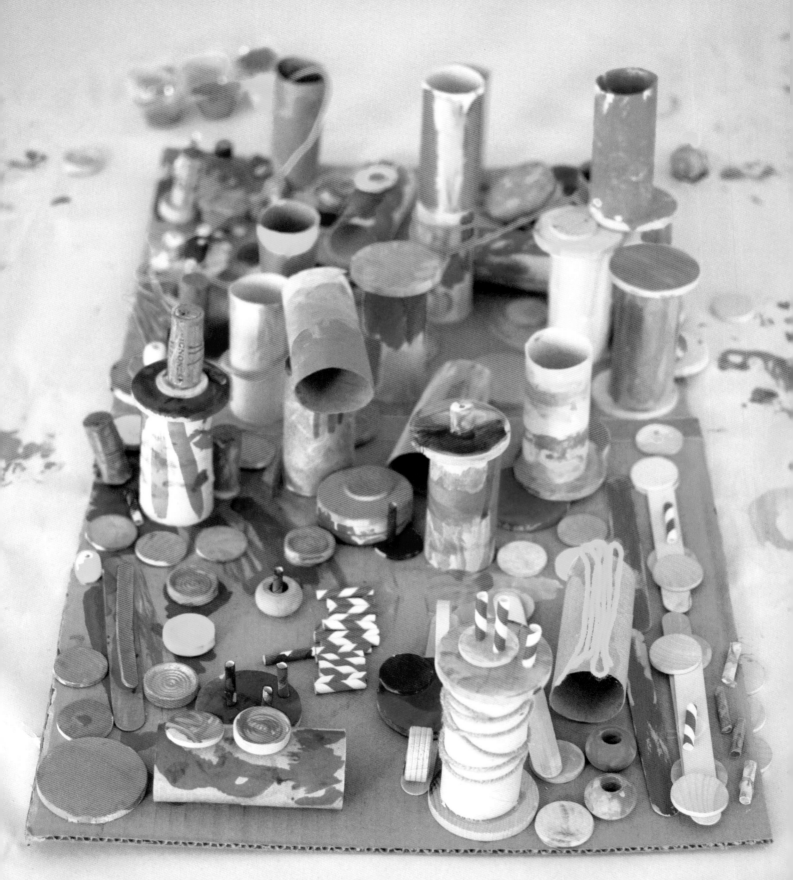

→ *Workshop 26*

ART CITY

This workshop, in which the children construct and build a city,
is a process-art collaborative experience where anything is possible.

GATHER YOUR MATERIALS

- Big piece of cardboard
- Paper rolls
- Glue
- Liquid watercolors or tempera paint
- Brushes
- Ideas for loose parts: straws, craft sticks, wooden pieces, wooden beads, corks, yarn

PREPARE YOUR SPACE

Cover your table with newspaper. Be prepared to leave this workshop out for a few days as the children continue to add to their work. Gather your loose parts and set out half of them on the first day. Bring a few new materials out each day. Allow your children to gather and add their own found objects if they desire.

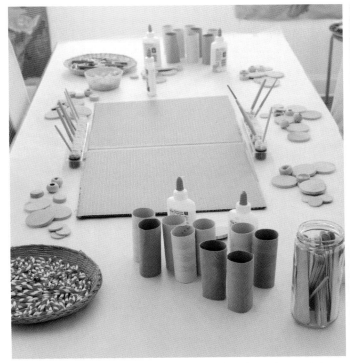

The children use an array of recycled and gathered materials to create a city together.

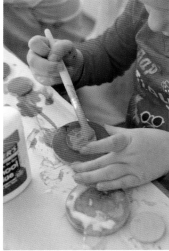

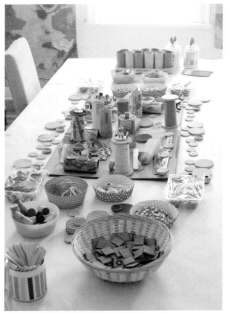

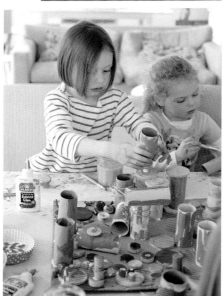

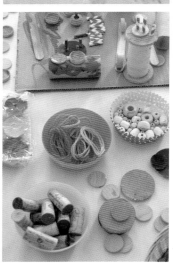

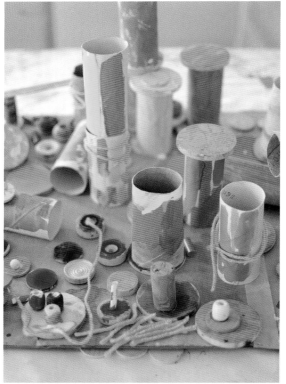

The children spend two days building their city together, using recycled materials and loose parts.

THE PROCESS

- As the children sit down, we talk for a moment about the different types of places where people can live. The children name a few, like houses, apartments, igloos, and boats. I tell them that these are all homes. Then we talk about towns and cities. They immediately are excited to make a city and get to work.

- There are no rules in this workshop. The children use their knowledge of the materials and their skills to build the city.

- At the next class, I set out more materials and a different type of paint, and again they are excited to get to work right away and add to their city.

OBSERVATIONS

I just love this workshop. The children are like busy little city workers, all of them completely engrossed in gluing, painting, balancing, assembling, stacking, and constructing. There is no shortage of ideas being generated. While some children keep their head down and concentrate deeply on their task, others become the project managers for the construction site. There are architects and engineers, decorators and landscapers. When a house falls down, an engineer swoops in to rebuild. As some work tall, others cover the ground. It's incredible how a group of creative thinkers can work together so seamlessly when they have a common interest. In the end, they unanimously named their work "Art City."

VARIATIONS FOR NEXT TIME

- If you have access to leftover wood pieces it would be fantastic to build a city from wood. You can buy wood pieces online, but it gets expensive. Building a wood city would make this more permanent, and the children could use it in their imaginary play. Use wood glue instead of school glue.

- Save creamer cartons and use them as houses.

- Have your child collect twigs and rocks from outside to use in building the city.

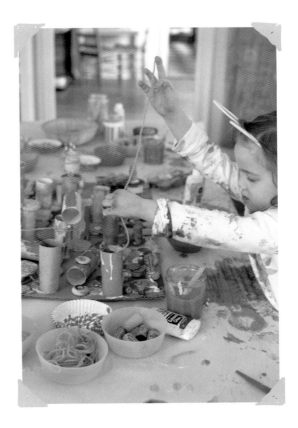

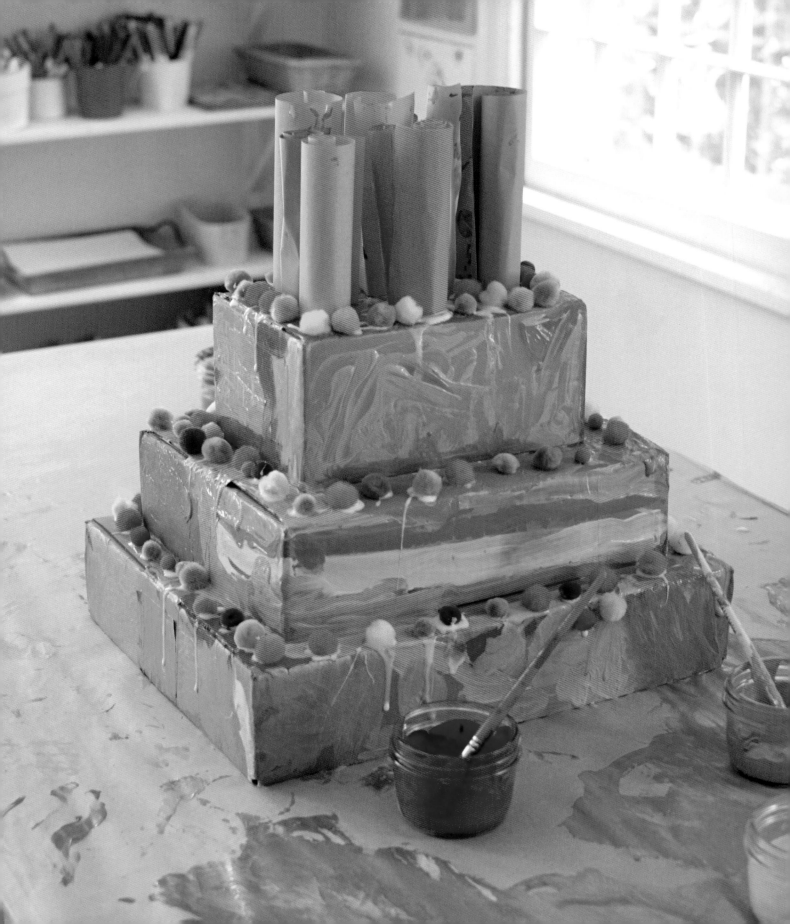

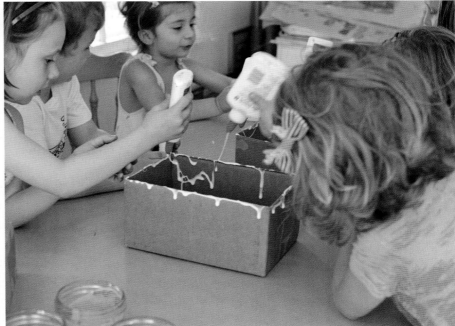

→ Workshop 27

CARDBOARD CAKE

Making a cake is joyful, no matter the age. In this workshop, the children work together to stack, frost, and decorate their big cake. Singing "Happy Birthday" at the end is a must!

GATHER YOUR MATERIALS

- Cardboard boxes in different sizes
- Tempera paint
- Jars
- Brushes
- Pompoms
- Glue
- Colored paper

PREPARE YOUR SPACE

Cover your table with paper. Gather some boxes in different sizes, or let the children choose their own boxes if you happen to have a large selection. Mix the paints, or have the children mix their own paints. I painted over the black tape that wrapped the boxes, but you don't have to. Set out pompoms, glue, and colored paper.

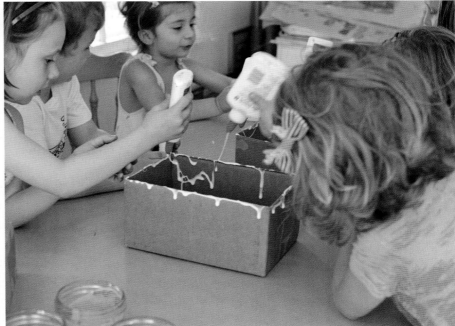

The children work together to glue and stack the different-sized boxes in order to make a cake.

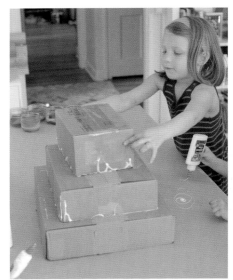

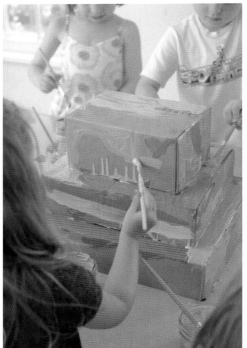

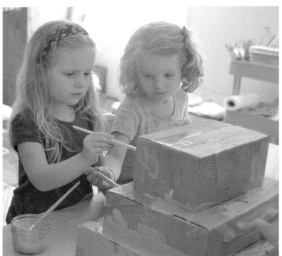

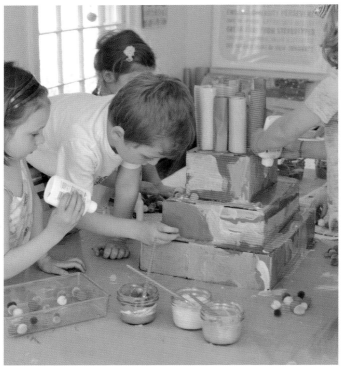

After the boxes are stacked and glued, the children frost and decorate their cake with paint and pompoms. They make candles from rolled paper.

THE PROCESS

- On this day in art class, I prepared the boxes for the children before they arrived. The boxes came in the mail the day before and they had a perfect size gradation. But in the future, I will most likely bring the children to my storage room and have them pick out their own boxes.

- After gluing the boxes together and painting the cake, the children take time to roll the colored paper candles. I showed the children how to roll tightly instead of loosely. Sometimes the bottoms need to be cut off in order for them to stand straight.

OBSERVATIONS

Imagine a group of children devouring a cake lickety-split. Well, that's what happened during this workshop, only in reverse. The children moved so swiftly building this cake that I hardly had time to photograph! Paint was literally flying across the table because they were frosting their cake with so much energy. I didn't even think of candles until one child had the idea of rolling paper. I had taught this technique in a previous session weeks earlier, so she found the drawer with the colored paper, shared her knowledge with her friends, and they all rolled candles together and glued them on top. Last of all were the pompom candles. They slowed down a little during this part, as they all were being careful to line them up evenly around the cake. I was captivated by their teamwork and dedication to each other in making sure that everyone played an equal part. This creative collaboration ignited a spark in these children. And what a delicious cake!

Overheard:
"Let's turn the cake so we can all paint every side."
—Sean, age 5

VARIATIONS FOR NEXT TIME

- Make an upside-down cake with the smallest box on the bottom. This would be a wonderful experiment about balance.

- Use really big boxes—big enough for a child to fit in—and make the cake into a playhouse.

- As a non-messy alternative, make homemade play dough and let your children stick play dough all over the cake instead of painting. They can stick pompoms and real candles into the play dough. This would be a wonderful sensory experience.

→ Chapter 6

Making Art Visible

"The artist is not a special kind of person; rather each person is a special kind of artist."

—ANANDA COOMARASWAMY

Children are prolific producers of stuff. From their first drawings of a real person to the pile of art that comes home from school, it's hard to know what to do with it all. One thing is certain: it must be shared and talked about, and it must be displayed! In this next chapter, Betsy writes a wonderful piece about how to talk to your children about their art. There is definitely an art to talking about art, and a way to understand your child's thinking and creative process, without judgment. I then show you many different ways to hang and display your child's art. Whether you curate the art together, or you do it when they are not home, hanging their art up for the whole family to see sends your child the message that their creativity is highly regarded. Best of all, it makes your home more beautiful.

TALKING TO CHILDREN ABOUT THEIR ART: IT'S A ROCK LIFTER!

Mom (me): I love your elephant!

Son: Mom, this is not an elephant. This is a machine that moves rocks. It is a rock lifter. The front of the machine is a long hose that sucks up the rocks like our vacuum. I am taking away the rocks so the boy can play.

I remember well when those words came out of my mouth, and I remember even more clearly how I wished I had never said them.

How I wish I had said:

- *Wow, you have worked so hard on this drawing!*
- *Tell me about what you've done.*
- *I see there is something very long in this part of the picture.*
- *What are you thinking?*
- *I notice that you have used a lot of red and yellow.*
- *In this part of the picture, your lines go round and round and round.*
- *I can tell that you have spent a lot of time thinking about this idea you have drawn.*
- *You seem very happy about what you have done!*

The questions and comments above are provocations. Ways to open the door for more conversation from the child. An invitation to share what the artist is thinking.

Not only had I mistakenly called his rock lifter an elephant, but I had also called it "great." What did I mean by "great"? How do you measure "great"? As a child, how do you live up to "great"? And does every picture now need that same high-expectation response?

"I love," "That's great," "I like," "That is so good" . . . are comments that hold judgment. They do not tell children you have noticed the details of their creative expression. They do not acknowledge their effort in the process. As adults, we have been led to believe that praise is a motivator and a way to support a child's accomplishments. Be careful, as this is a slippery slope.

Instead of providing empty praise, we just need to pay attention to the very simple gestures and details the child has provided. To start, we can share simple noticings about the child's process that relate to color, space, texture, size, and material.

- *It is so blue.*

- *It is enormous.*

- *This bumpy corner is so tiny.*

- *You have used all of the paper.*

- *You put string through the small holes.*

The greatest gift we can give our children is to take the time to reflect, notice, and share a thoughtful response. Children know when they have our full attention. They can't be fooled on this one. Children have radar for this kind of thoughtful, intentional approach to listening:

- Stop.

- Get down at eye level.

- Make eye contact.

- Pause . . . they may begin.

- Offer comments or questions.

- Affirm their effort in the creative process.

- Appreciate how they see the world.

- Support and empower the value of self-expression.

- Leave them feeling inspired to do more.

- Love them for who they are.

- Savor every minute. It is fleeting.

These authentic encounters can accumulate into a lifetime of uninhibited and positive creative expression. What a gift!

—*Betsy McKenna*

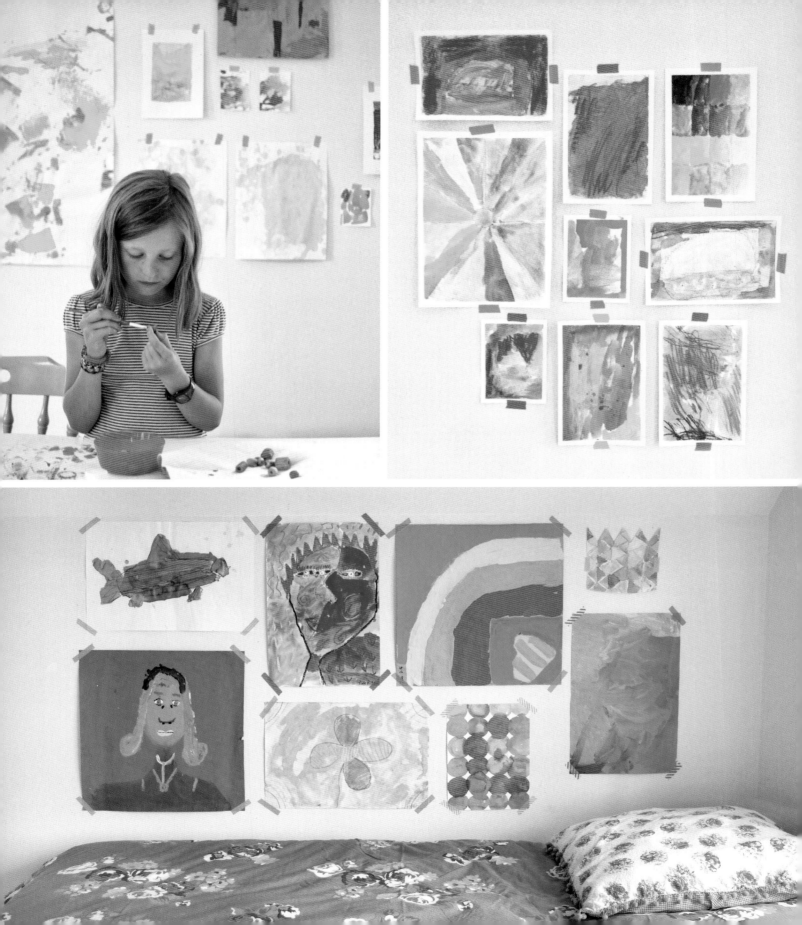

DISPLAYING YOUR CHILD'S ART

If you want to make your children happy, hang up their art. What might seem like an easy thing to do actually doesn't get done very often. Believe it or not, I am just as behind (and often lazy) as most when it comes to organizing and displaying my children's creative works. Through the years, things pile up! But I did spend some time framing art in their younger years and have one dedicated gallery wall. I also have several clotheslines here and there, which makes it easy to pop something up—when I remember.

Displaying your children's art makes them feel proud, it shows them that you care, and it sends the message that art is important and valuable in the life of your family. I have many ideas to share with you, from a simple clothesline to more expensive framing. You can find one big wall for a gallery display, or you can scatter a few important pieces throughout the house. Finding good spots is not the hard part. The hard part is getting up and doing it! I hope these images will inspire you to make it happen.

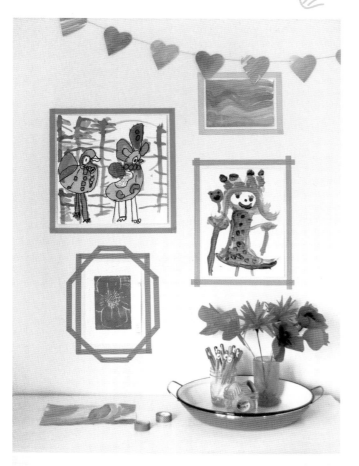

Gallery Wall (Taped)

The very simplest way to honor your child's creative work is to tape it up on the wall with some colored washi tape. Whether you start with one piece and then keep adding throughout the year, or you collect a whole bunch of artwork and do it at once, I promise it will bring joy to your child (and your wall). Every week I gather my art students' work from the week before and display it this way. (Some types of washi tape are not sticky enough so occasionally I will tape the back first with Scotch tape, then use the washi tape for a decorative effect.) As your children get older they can create their own gallery wall and add in photographs, quotations, posters, and whatever else speaks to them. One other really fun idea is to use the colored tape to make frames, then hang the art inside, rotating periodically when new things are made.

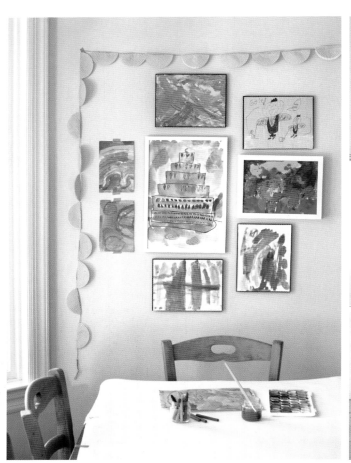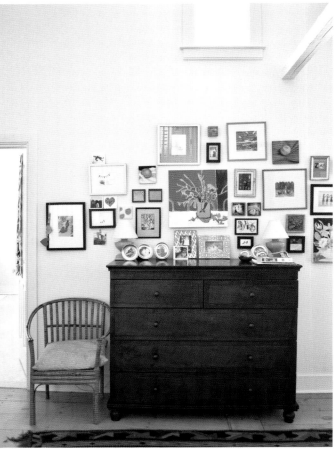

Gallery Wall (Framed)

I would say a framed gallery wall is the most effort of all the ideas presented. But not as much effort as, let's say, having a baby. And you did that. So this is really not hard at all. There are several ways you can go here. You can mismatch frames (which is my favorite way because it's less pressure), you can keep one consistent frame color but in lots of different sizes, or you can be completely disciplined and buy all of your frames the same color and size and create more of a grid. Any way you do it, you will be happy that you did. Framing a child's art is the highest of compliments.

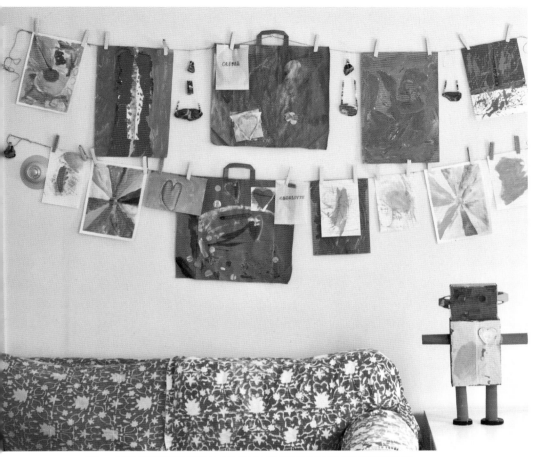

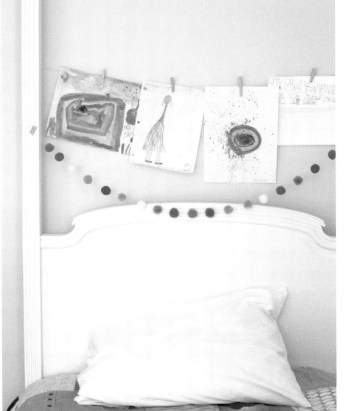

Clothesline

Hanging a clothesline and using clothespins to display your child's art is the least amount of effort, but with a very high return. There is such beauty in simplicity. And a clothesline already has such an organic, childlike feel that the artwork will feel right at home. You can hang a clothesline across a room in open space, or against a wall. If you have a small line—say, above a bed—then tape might be enough to secure the string. Otherwise, you might want to hammer a teeny nail into the side of the molding.

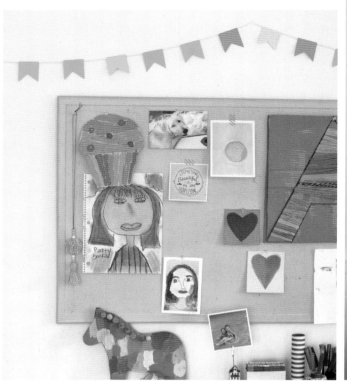

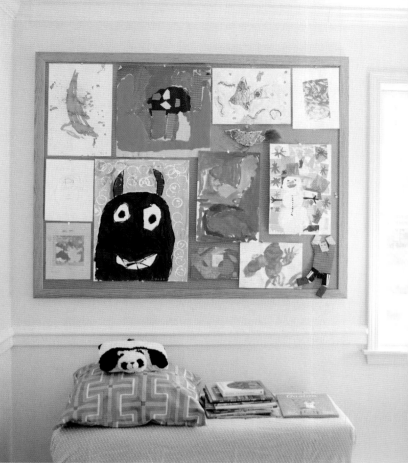

Corkboard

I do love a nice corkboard. It guarantees that everything will be contained in one place, and using pushpins is very easy and convenient for children. If you have crawling babies or barefoot toddlers in the house, be sure to keep the pushpins in a safe place. Sometimes we use tape on our corkboard to avoid the holes. You can buy inexpensive corkboards and cover them with latex paint in bright colors. This makes them feel more modern. I do still have a soft spot for brown cork. It has a bit of a retro '70s vibe, which reminds me of my childhood. You can buy cork squares and put them together to make one giant cork wall, which creates quite a statement, or buy a big one that is already framed. Corkboards also make it easy to cycle new art in and out.

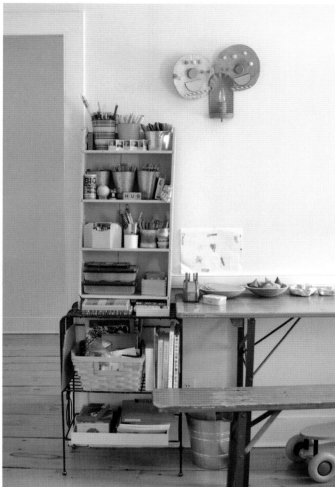

Vignettes

This is probably my favorite way to display my children's art throughout the house. It takes no effort at all, just finding the right little spot. I love being able to walk from room to room, passing some of my favorite pieces. It makes the house feel arty and it makes my children happy to see that their creativity is the highlight of our home.

ABOUT THE AUTHORS

Bar Rucci is passionate about two things: children and art. She is a professional graphic designer, art teacher, blogger, and mom to three creative thinkers.

Bar graduated from Skidmore College with a degree in art and a minor in early childhood development. After college, she spent a decade on artistic entrepreneurial pursuits. She painted murals, designed textiles, created a children's clothing line, and finally taught herself graphic design. It was this last venture that became her calling, allowing her to stay home and raise her children.

In 2012, she began her blog *Art Bar*, a place where she explores her love of child-led art experiences and handmade things. Soon thereafter she began teaching art in her home.

Bar lives with her husband, three children, and shedding labradoodle in Connecticut.

For more inspiration and resources, visit Bar's blog and follow her on social media:

Website: artbarblog.com
Instagram: @artbarblog
Facebook: facebook.com/artbarblog
Pinterest: pinterest.com/barrucci
YouTube: youtube.com/c/artbarblog

Betsy McKenna, M.Ed., is a firm believer in the brilliance of the young child and their natural born creative process. A Reggio–inspired teacher and administrator, she is passionate about creating high quality educational opportunities for all children. She currently resides in New York City as an educational consultant and leadership coach, and has three grown children who remain her greatest source of inspiration.

Visit Betsy on her blog and social media:

Website: exponentialreturns.org
Facebook: facebook.com/exponentialreturns
Instagram: @betsymckenna1
Twitter: @betsymckenna1

*To Grace, Ava, and Nate, who amaze me every day with
their creative intelligence, their humor, and their bravery.*

—Bar Rucci

*To all adults who influence the lives of young children.
Be forever in pursuit of your creative spirit. You are born
with one so, hold on tight and don't ever let it go!*

—Betsy McKenna

ACKNOWLEDGMENTS

This book would not even be in existence if it weren't for a conversation I had with my friend and co-author, Betsy McKenna, one August afternoon in 2014. As she sat in my living room, the tables and walls covered with children's art from a recent class, she suggested collaborating on a book series. Thank you for believing in me, Betsy, and for recognizing that it was time we made something together! I am endlessly grateful for your trust and wisdom, and so very happy that we created this *real* book, which is meaningful, artistic, and everlasting.

I owe a great deal of gratitude to Mary Ann Hall, my editor, who convinced me that a printed book would hold so much more value than my original idea of creating an e-book series. Many thanks, Mary Ann, for respecting my vision, and for always being kind and patient.

To my Rockin' Art Moms, thank you for raising my game and for always being there when I need you. I am especially grateful to Meri for bringing me into the circle; to Ana, for taking the time to be our leader; to Rachelle, Megan, Gina and Merrilee for coming to ALT and making me feel like the luckiest girl alive (nothing beats hanging out together in person); to Jean for being our pioneer; to Asia for being my cheerleader; and to Ami for your ever-present optimism. I would be nothing without your friendships!

I am forever grateful to my local friends and neighbors, Kaitlyn, Marnie, Stacy, Christian, Ann, Jen, and Whitney. You cooked meals for me, watched my children, brought me balloons, and gave me pep talks when I needed them most. Your generosity and love mean more than you will ever know! Thank you, also, to the Lowe family, the Murphy family, the Parker family, and the Carrillo-Foote family for lending me your homes. You saved me!

Thank you to the children who appear in the pages of this book. I am so lucky to have you as my students! You are not only fun and funny and smart and imaginative, you are also kind to each other and that's the most important thing of all. I will never forget you! Thank you to your parents, too, for nurturing your creativity and believing that art is an important part of your life. And for driving you to my classes!

Most of all, I thank my family for their enduring love and support. To Marysue for your advice and wisdom in my time of need; to my in-laws, Debbie and Joe, who are the most genuine people I have ever known, thank you for your guidance, and for loving my children; to Dad for inspiring me with your magnificent paintings, and to Ann for patiently supporting me through all of my creative endeavors. I owe so much of who I am to my mom, the person I look up to most in this world. Because of your grace, your integrity, and your strength in the face of obstacles, you have shown me how to live my life with kindness and forgiveness. To Grace, Ava, and Nate, who are my anchors in life. I cherish every piece of art you have ever made, and every note you have written to me. I love you more than words! Most of all, I am forever grateful to my husband, David, who loves me despite the paint-splattered living room and kitchen full of "stuff I'm saving". Thank you for never wavering in your support of my vision, and for being my counselor and my friend. I am so lucky to have this life with you.